# AIRBRUSHING

# TECHNIQUES

# Step-by-step

Roland Kuck

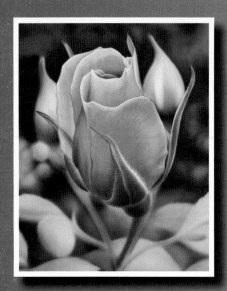

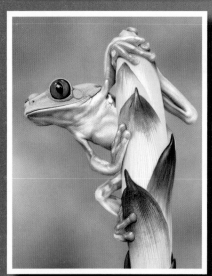

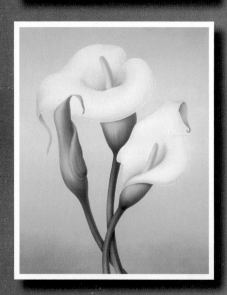

I should like to take this opportunity to express my thanks to all those who have helped me to compile this book.

I should like to thank Mr Fischer from Edition Michael Fischer publishers, who made a significant contribution to promoting airbrush art by publishing the German edition of this book.

Further thanks go to Verlagsservice Henninger, especially Mrs Hanne Henninger, for their excellent co-operation.

My especial thanks go to the Director of the Kunstschule für Airbrush-Design, Monika Wrobel-Schwarz of the IBKK, for her competent and untiring advice, for her general support and for her willing co-operation with this book.

My thanks also go to the art historians Dr Bernd A. Gülker and Dr Regina Schymiczek from the IBKK for their proofreading.

I should also like to thank Picture-Alliance/dpa, who granted the IBKK usufruct of the portrait photographs as a basis for painting the portraits of Desmond Tutu (page 143), Queen Rania of Jordan (page 144) and José Carreras (page 144).

Thanks go as well to the following photographers, who also made portrait photographs available as a basis for the portraits painted: Norman Schreiber from Internews for the portrait photograph of Robin Gibb (page 142); Jens Nagels for the portrait photograph of the Dalai Lama (page 143); and Klaus Möller for the portrait photograph of Axel Schultz (page 144). Thank you also to Internews for allowing use of the portrait photographs of Her Imperial Majesty Farah Diba Pahlavi and of Michael Gorbachov as a basis for the paintings on page 143, and to UNESCO for making available the portrait photograph of Phil Collins (page 144).

My thanks also to the photographic agency Fotolia and the photographer Mark Kostich for the photograph of the frog that I used to paint the picture.

Thanks also to the photo-designer Klaus Möller for the photographs of the Kunstschule für Airbrush-Design, and the artist Peter Phillips for kindly allowing printing rights for his work Custom Painting (page 9) in the Binoche Collection, Paris. I should also like to thank the companies Harder & Steenbeck and Createx, and, in terms of artistic requirements, Monika Wrobel-Schwarz for making available photographic materials and various airbrush devices and paints.

First published in Great Britain 2010 by Search Press Limited, Wellwood, North Farm Road, Tunbridge Wells, Kent TN2 3DR

Reprinted 2011

Originally published in Germany 2008 by
Edition Michael Fischer GmbH, Igling

Text, pictures and layout copyright © 2008 Roland Kuck

Photographs copyright © with the photographer mentioned.
For all the other photographs:
copyright © 2008 by Roland Kuck
copyright © Peter Phillips, Custom Painting, page 9

English translation by Cicero Translations
English translation copyright © Search Press Limited 2010
English edition edited and typeset by GreenGate Publishing Services

ISBN: 978-1-84448-524-6

Printed in Malaysia

# AIRBRUSHING
# TECHNIQUES
## Step-by-step

Roland Kuck

SEARCH PRESS

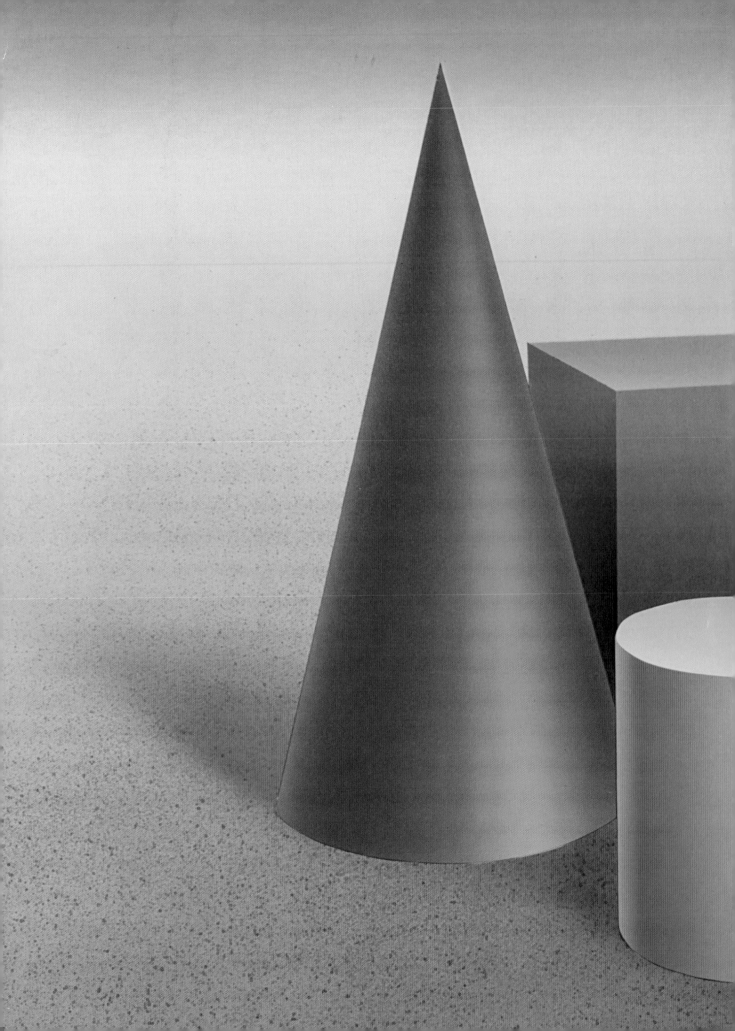

# CONTENTS

# Foreword

Dr Bernd A. Gülker,
art historian

The airbrush has lost none of its appeal over the 100 years or so since its appearance. A spray gun can provide endless possibilities for artists, including illustrators, sketch artists and painters. The full spectrum of styles and approaches ranges from realistic and photo-realistic art and illustration, through to painting and freehand experimental use. The motifs, content and themes of airbrush art are equally wide-ranging. As well as classic genres such as still life, landscapes and portraits, animals and objects are also popular, along with the fairly obscure field of fantasy illustrations, as well as mythological and biblical scenes. All of these can be created using an airbrush on conventional picture surfaces such as canvas or card. In addition to this is the extensive field of custom painting, as airbrush art can be used on virtually any base.

The basic technique for airbrush design has barely changed over the years. It still consists of the simple and effective principle of spraying paint using compressed air, skilfully applying it to a base to produce motifs, in which pictorial expression can go beyond the effect of a photograph.

If one wishes to be able to make full use of the technique and its creative possibilities, a working knowledge of how to use other materials and tools, such as paintbrushes, pens, paints and erasers etc., is required, in addition to a basic knowledge of how to use an airbrush.

This book covers the basic principles of the airbrushing technique, focusing on the artistic use of the airbrush gun. In a way that is both clear and easy to understand, it shows both beginners and the more advanced how to handle a spray gun correctly. Even those with no previous artistic knowledge can benefit from the author's experience and expert tips, and learn how to perfect their technique.

The richly illustrated projects in this book include detailed step-by-step instructions for how to reproduce the paintings. A demonstration of each project is also provided on the accompanying DVD. The instructions can easily be adapted to create pictures of your own, and all of the projects enable the reader to acquire the basic knowledge needed to tackle more complex artistic projects.

The airbrush 'boom' of the 1960s and 1970s spawned a new generation of interested users, many of whom were at the start of their development and keen to benefit from the many years of

experience of their elders. In this specialist book, the artist Roland Kuck presents his well-known working methods, accompanying readers from their first attempts with this versatile piece of equipment right through to achieving a photo-realistic airbrush picture.

In the middle of his artistic career, Roland Kuck moved on to the biggest challenge of them all: the portrait. His portraits of prominent contemporaries convey a personal, almost intimate, approach to individuals from areas as diverse as politics, culture, sport, the Church and the economy. Roland is a master of the freehand technique when using the airbrush gun. He uses it to give his portraits an unusual naturalness. His portraits include faint tones with softly graded shades dominating, and character-giving nuances transforming the initial material into a lively likeness. The results of his artistic transformation are impressive, requiring a high degree of discipline as well as a lot of work.

Since 1990, Roland has guided numerous students from their first tentative steps through to creating a detailed piece of work in his role as a lecturer in Art and Art Therapy at the *Institut für Ausbildung in bildender Kunst und Kunsttherapie*. His comprehensive knowledge has helped them enormously.

I hope that this publication awakens in the reader a long-lasting interest in this exciting artistic/creative technique. It is both an introduction for beginners to help them overcome their initial difficulties, and a source of advice for the more advanced artist to build on what they have already learned.

Dr. phil. Bernd A. Gülker
Art historian

# The history of the airbrush

An airbrush is a device that atomises paint or fluid using compressed air.

The date that the first spray gun was invented is a matter of dispute. In Japan, spray art has been recognised since the 17th century. In the West, the aerography technique of painting was first recognised in the 19th century.

Details differ about the inventors and the dates given for inventions and patents.

A name that is often connected with the invention of the first spray gun is Charles Burdick. It is quite likely that the way his invention was constructed has barely changed to this day, and that these models have entered the market as airbrush guns.

The American Charles Burdick came to Europe in 1893, where he patented the first aerographs in England.

He founded the Fountain Brush Company in the London area, and introduced the first series of spray guns on to the market.

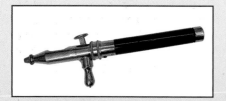

*A Charles Burdick spray gun.*

Charles Burdick himself was a watercolour painter, who wanted to use his invention to overlay several glazes of paint without smudging the first layers again with the brush.

By using the spray gun, he was, for the first time, able to apply perfect colour fade-outs without patches or smudging of the paint. Burdick drew up a series of sprayed sample watercolours and sent them to the Royal Academy of Arts for its annual exhibition.

The pictures were refused, not because of a lack of artistic quality, but because the academics

deemed the spray gun to be a mechanical aid to painting.

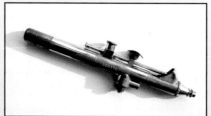

*This 'Sprio' spray gun probably dates back to the 1930s.*

Some years previously, in 1879, Abner Peeler had already invented a mechanical brush that was called the Paint Distributor. This invention was used for retouching photographs and for portrait paintings. The later Paasche AB Turbo operated in the same way (see below). Peeler sold his invention to Liberty & Charles Walkup, who developed the Paint Distributor further.

This airbrush probably served as the basis for the turbine-driven airbrush gun invented by Jens Paasche in 1904, the Paasche AB Turbo.

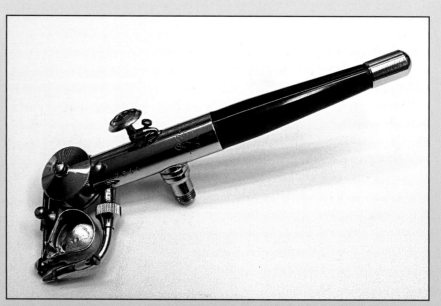

*A Paasche AB Turbo. The method of operation is based on that of Abner Peeler's Paint Distributor.*

**Spray equipment has changed very little between the registration of the very first patent to the present day, with the method of construction being essentially the same.**

**Sources of compressed air have fortunately improved. The conventional foot or hand pumps used in the early days have been replaced by modern, quiet-running compressors.**

In 1918, the American painter Man Ray (Professor of Art, Sculpture and Photography, and co-founder of the Dada Movement in 1915 in New York) discovered the airbrush as a new form of expression, and painted a series of paintings that were exhibited in Paris under the title *First Objects Aerated*.

This exhibition was a complete flop. European art critics described Man Ray as a degenerate, charlatan and criminal who would bring disgrace to the art of painting by using mechanical tools.

In the 1920s, the Bauhaus school of art was founded in Weimar, Germany, and there, under the spiritual guidance of the architect Walter Gropius and the co-operation of renowned artists such as Paul Klee, Wassily Kandinsky and Mies van der Rohe, the synthesis of art and technology was proclaimed. As a result, the spray gun was accepted alongside all other artistic media, such as brushes and pencils. Although Bauhaus was dissolved in 1933 by the National Socialists, the idea of the German Bauhaus movement lived on with the opening of the 'New Bauhaus'

in Chicago in 1937. During this period, the spray gun was used mainly in advertising, for retouching photographs and in graphic design.

The 1960s saw the development of Pop Art, an art form that indiscriminately used all artistic means of expression, such as oil, acrylics and airbrushing. The initial focus was on advertising images and commercial art.

The most famous artists were Andy Warhol, Roy Lichtenstein and Robert Rauschenberg, as well as Peter Phillips and

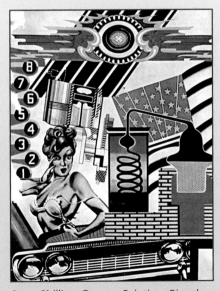

*Peter Phillips, Custom Painting. Binoche Collection, Paris.*

Allen Jones. Phillips and Jones exclusively used the spray gun for creating their paintings.

In the mid-1960s, there were several exhibitions of large-scale photo-realistic paintings in New York.

Pop Art, which pursued photo-realism or hyper-realism, succeeded in a complete breakthrough in 1972 at the Paris Biennale art festival.

The spray gun is particularly suitable for this style, as it requires such a perfect and pure composition. Artists such as Chuck Close, Don Eddy and Audrey Flack used the spray gun for their photo-realistic works. This artistic movement meant that the airbrush became widely accepted, whereas previously it had been scorned.

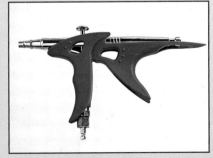

*Spray guns have changed in appearance, but the technology has remained the same.*

# Airbrush

FineArt

# MATERIALS
## and their uses

# Pigmented airbrush paints

## Pigmented airbrush paints

Airbrush or fine-spray pigment paints are usually ready-to-use acrylics that can be thinned with water. The paints have very fine pigments, together with high non-fade properties and high colour concentration. The paints adhere to virtually all clean, grease-free bases. Airbrush paints can be thinned with the appropriate medium, tap water or distilled water.

To retain the adhesive properties of the paint, medium should be added if the paint has been significantly thinned.

Airbrush paints are usually available commercially in pipette bottles or in bottles with a drop-counter cap. Both transparent and opaque paints are available, and even the opaque paints can be made transparent if sufficiently thinned.

### Airbrush paints

The airbrush paints from different manufacturers have different properties. There is therefore no general rule for the exact mixing ratio of paint, water and/or medium.

The concentration of the pigments and the viscosity (thickness) of the paints, as well as the air pressure and nozzle diameter of the airbrush gun, all have an effect on the final result.

All ready-to-use airbrush paints should be shaken well before use. Some of the paints have a very high pigment concentration, which causes the pigment to settle at the bottom of the paint bottle. These pigment deposits must be completely loosened from the base of the bottle by shaking, so that no discrepancies occur in the paint when it is being applied.

With older paints, small lumps of paint sometimes form that cannot be shifted, even when well shaken. These paints should be filtered through a fine paint strainer, because otherwise the lumps will block the nozzle of the airbrush gun, preventing smooth-flowing, uninterrupting work.

When spraying colour-intensive surfaces or fade-outs, the paint can only be used in its pure state or slightly thinned.

Greater thinning is required for very transparent or fine work. Most airbrush paints work better when they are significantly thinned. This means that the air pressure can also be reduced, which in turn reduces the degree to which the paint is atomised. The spray gun should be cleaned with the manufacturer's recommended cleaner after use or when changing colour.

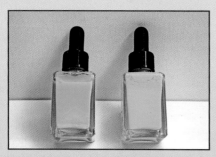

*Pigment deposits can be seen in the bottom of the bottle above left, and are absent in the bottle above right, which has been shaken.*

## Airbrush primer

The majority of primers available for airbrushing work are colourless and can be thinned with water. Many of them are for universal use. The main purpose of using them is to improve the adhesion of the airbrush paint. In most cases, porous bases, such as fabric, canvas, paper or drawing board, should not be primed.

Some bases that are painted or decorated with a spray gun require special pre-treatment and/or primer. Smooth, non-porous materials, such as lacquered surfaces, glass, ceramic or plastics, must additionally be given a key for the paint to adhere to, or a matt finish. All surfaces should be clean and free from dust or grease.

### Airbrush primer

A virtually colourless primer should be used when working on non-porous bases (lacquer, plastic, metal, etc.).

Primer can be used on paper or card, but it is not essential. Depending on the quality of the surface, primer can help make the paint adhere better. It is also an advantage to have a primed surface when using masking film, which is needed when erasing, scraping and scratching.

Most airbrush primers can be thinned with tap or distilled water, as the primer is usually fairly thick and would otherwise need to be used with higher air pressure.

The surfaces to be primed are often fairly large, which is why a gun with a large-diameter nozzle and large paint reservoir is used.

For large-scale work, such as on airbrush or drawing board, a wide, flat brush is also suitable.

When the primer is applied, care should be taken to ensure it is not too wet, otherwise the base (paper/card) will buckle. After applying the primer, the base should be allowed sufficient time to dry.

Primer should be applied carefully to non-porous bases using the spray gun. If applied too wet, the primer has a tendency to form droplets. Whatever the base, it is important to apply the primer as evenly as possible, as it changes the surface properties of the base (absorption, matt or shiny spots), which can also affect the paint effect of the subsequent airbrush work. Moreover, non-porous bases (such as lacquer, plastic, etc.) should be additionally prepared by removing any grease and giving them a key.

# Media and additives

## Media and additives

Various products are available for use with airbrush and acrylic paints. These additives can improve adhesion with problematic bases, delay or reduce drying time, alter the surface properties of the paint, or affect the viscosity of the paint.

### Airbrush primer

Most transparent water-based primers are designed to improve the adhesion of airbrush paint to various bases.

The primer should be slightly thinned and applied thinly and evenly in several layers.

The sealed surface of the primed paper or card is better suited to the use of self-adhesive masks when erasing or scraping with a scalpel.

### Airbrush medium

The term 'medium' usually refers to a product that can also be used as paint thinner.

To make very transparent paint that does not lose its adhesive properties, airbrush paints should not only be thinned with water, but also have an airbrush medium added as well. Some media can also affect the surface properties of the paint. Media with different levels of shine, such as matt, silk and gloss, are available commercially.

Media not only increase resistance to wiping and water, but also change the behaviour of the paint when erasing and scratching. Precise instructions on the mixing ratio of paint and medium and their thinning cannot be given because different products have different requirements. It is a good idea to try out the various media for yourself.

### Textile medium

In order to make airbrush paints adhere better to fabrics, a special textile medium can be added to the paint.

To ensure that the work adheres well to the fabric, the manufacturer's instructions should be followed carefully. They will provide details of the pre-treatment required, mixing ratios and the manner of fixing.

The instructions on cleaning the fabrics should also be followed. In most cases, a gentle handwash is required.

### Leather medium

This additive is used to improve adhesion to leather bases. Depending on the manufacturer, the medium can be used as both a primer and a seal for airbrush work.

When using a leather medium, the manufacturer's instructions should be followed carefully. These state the ratio of paint to be mixed, how to pre-treat the base and how the work should be sealed. When painting leather bases, it is important that the base is completely free of grease.

### Retardants

These are available for airbrush and acrylic paints. As the name suggests, this additive ensures that the paint dries more slowly. The advantage of retardants is that when working with the spray gun, the paint does not stick to the point of the needle so quickly. When using a retardant, the manufacturer's instructions for mixing should be followed carefully in order to avoid using too much and thereby preventing the paint from fully drying.

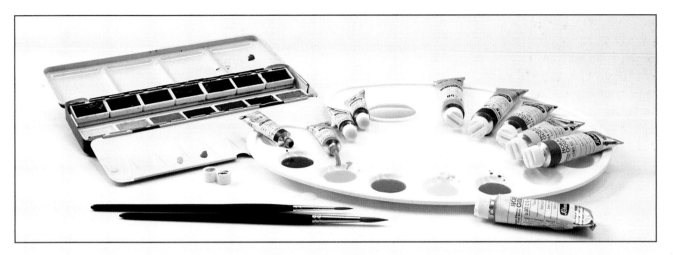

## Sealant

In order to protect airbrush work built up with thin layers of paint, water-based transparent lacquer can be sprayed on as a seal. Sealants are available in various shine finishes, such as matt, silk or gloss, and can contain ultraviolet (UV) protection. They should be applied with a spray gun, as using a brush or roller can smudge the airbrush paint and ruin the work.

This type of coating enables water-soluble paints such as gouache or watercolours to be sealed and made watertight.

## Watercolours

Watercolours are also particularly suitable for working with a spray gun. The paints are supplied commercially in tubes or little pots, and must be made ready for spraying by thinning with tap or distilled water.

Watercolours are characterised by their transparency and brilliance of colour. One advantage of these paints is that they remain water-soluble. This means that the airbrush gun rarely becomes blocked. However, this feature means that the watercolours must be applied carefully so as to prevent the colours from accidentally running. To give the paints better adhesion, there are a number of aids available, including shellac soap. These additives make the watercolours more waterproof.

## Gouache paints

A popular paint used for illustration is opaque gouache. This paint can only be sprayed when used with water, although care should be taken not to lose the opaqueness of the paint completely.

This paint is available in various grades. The level of pigmentation is crucial for working with a spray gun. Fine pigments are better for working with the airbrush gun. The paint can be sealed with a coat of water-based lacquer.

## Acrylic paints

Acrylic paints are available in tubes or bottles and can be sprayed when water and/or medium is added, which affords them very similar properties to those of ready-to-use airbrush paints. Depending on the grade and pigmentation, these paints should be used with an appropriately sized nozzle. Thinned tube paints should be strained before use.

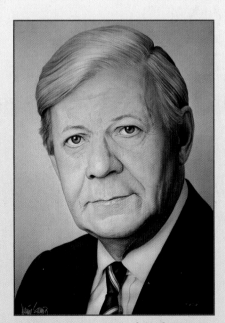

*A watercolour portrait of the former German Chancellor, Helmut Schmidt.*

# Additional colours

Solvent-based paints have some advantages. When using these paints and additives, particular care should be taken to follow the health and safety guidelines.

## Lacquers

Some types of airbrush art require paints that contain lacquer or solvent.

In the field of custom painting, i.e. painting particular items, especially motorcycles and motor vehicles, lacquers and special-effect lacquers offer a wide variety of options. Lacquer paints or lacquer glazes have good adhesive properties and are easy to use. They are generally very resistant to fading and have a strong luminosity.

As versatile and advantageous as they are, these solvent-based paints can be very harmful. When using these products, safety guidelines should therefore be followed carefully.

When using lacquers, a good dust respirator is mandatory, and the use of a spray booth with air extraction is preferable.

Another important aspect is the tool that is used. Not all airbrush guns are suitable for working with solvents.

Seals should be made of a material that will withstand the use of solvents. Disposal of waste lacquer and the thinner used must meet with environmental guidelines.

## Oil paints

Oil paints can also be used for painting with a spray gun, with the appropriate thinning with balsamic turpentine and with the possible addition of a drying accelerator.

Some commercially available paints are harmful, and a dust respirator should always be worn, even when working with thinned oil paints.

When choosing the base, consideration should be given to the fact that oil stains some bases, such as paper or card, and that oil paints take a long time to dry.

When cleaning equipment used for oil paints, turpentine or another solvent should be used. A check should consequently be made beforehand to ensure that the airbrush gun can withstand solvents.

## Bases

Paper and card are the preferred bases for airbrush art and illustrations. It is, however, recommended you practise on drawing or sketching paper; different types of paper should be tried out to familiarise yourself with the advantages and disadvantages of the various types.

### Paper and card

The preferred base for airbrush illustrations is paper or card. There are numerous different types that vary in terms of texture, colour, weight and surface quality.

Textured or coloured paper is good for artistic work, whereas very smooth bases are more suitable for technical illustrations.

Depending on the type of work, the base may need to be pre-treated. Paper and card produced specifically for airbrush work is suitable for most purposes.

Paper or card can be freed of grease before painting or sealing by using benzine (petroleum ether). If there are fingerprints on the surface of the paper, these are usually visible only once the surface has been sprayed. Some types of paper must be pre-treated with airbrush sealant if they are intended for use with self-adhesive masks or erasers.

It is advisable to try these out in advance to avoid any unpleasant surprises.

### Lacquered surfaces

First of all, it is important to establish the type of lacquer (acrylic, synthetic resin, etc.) that is on the base – this is important in terms of how to proceed. All the materials used must be compatible so that there are no unwanted reactions between them.

The base must be thoroughly cleaned and free of grease. To remove grease, use a silicon remover, benzine or ox gall. Then key the surface to make it matt.

To do this, wet abrasive paper with a grain size of 1000 or 1200 is used. Alternatively, a suitable abrasive fleece or abrasive pad can be used. The cleaned surface can then be pre-treated with airbrush primer. When thinning water-based airbrush paints, airbrush medium should be added. If these paints are thinned only with water, they will very quickly form drops on the base. A range of solvent-based paints is available for lacquer design.

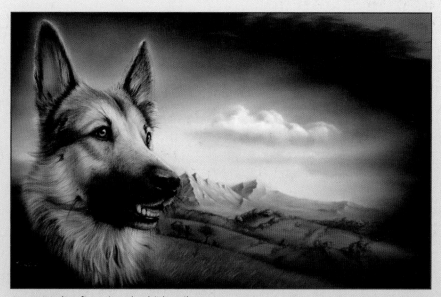

*An example of a painted vehicle tailgate.*

# Bases

Virtually all bases are suitable for airbrush art. Airbrush art can be found on diving cylinders, fingernails, textiles, bodies, hair, cars and motorbikes, on walls, mobile phones, satellite dishes and aeroplanes. In fact, there is probably no firm base that has not yet been decorated using an airbrush.

For many bases, however, pre- and post-treatment is necessary in order to ensure adhesion of the airbrush work or its durability. This pre- and post-treatment often involves lacquers or other harmful materials, and should be performed by professionals, leaving the airbrush artist to focus on his or her artistic creations.

Solvent-containing paints work very well on lacquered surfaces, as the paint dries out very quickly due to the solvent.

Nevertheless, a very good dust respirator is needed and, where possible, a spraying booth.

N.B. Self-adhesive masks or films should not be used on freshly lacquered parts while there is still solvent in the lacquer. The adhesive on the film can be affected by the solvent. This could also result in the adhesive from the film sticking permanently to the base.

Ideally, a period of three to four weeks should be left between lacquering and using masking film.

### Plastic
With plastics, it should be borne in mind that most pieces are pressed or poured into moulds. Separators are used for this, which must be removed without trace before painting or lacquering. It is also important before lacquering to check the compatibility of the material with solvents.

The variety of plastics used for model construction, mobile phone casings, spectacle cases, games consoles, toilet seats, etc. means that there is no all-embracing rule for pre- and post-treatment.

Smooth surfaces can be keyed with wet 1000/1200 grain abrasive paper, while abrasive fleece is better for textured surfaces. Depending on the type of plastic and its use, a special plastic primer might be needed.

When lacquering plastics, the use to which the items will afterwards be put should be taken into consideration. Parts that will be subject to bending or twisting should be given a flexible sealant.

Particular care should be taken when painting crash helmets, as these are subject to special safety requirements and, in general, are not meant to be worked on. If in doubt, consult the manufacturer's instructions.

Airbrush medium should be added to airbrush paints that require thinning for plastic bases. Paint that is too watery has a tendency to form droplets, and the medium improves the adhesion of the paints.

*A spare wheel cover made from fibreglass-reinforced plastic.*

# Bases

Canvasses are available in a wide variety of formats and with very different surface textures.

## Canvas

Canvas is a popular base for artistic airbrush work. It is available in virtually all sizes on a roll or stretcher, and is very easy to work with.

Most commercially available canvasses are already pre-treated with universal primer or gesso.

Canvasses are available with textures that range from very fine to very rough. The surface texture of the canvas should be selected according to the type of motif to be painted. For very detailed work with fine fade-outs and the depiction of smooth surfaces, a very finely textured canvas would be the best choice.

In some circumstances, an extra prime of the canvas with gesso can improve the surface properties for airbrush painting, as this primer can smooth out the texture of the canvas.

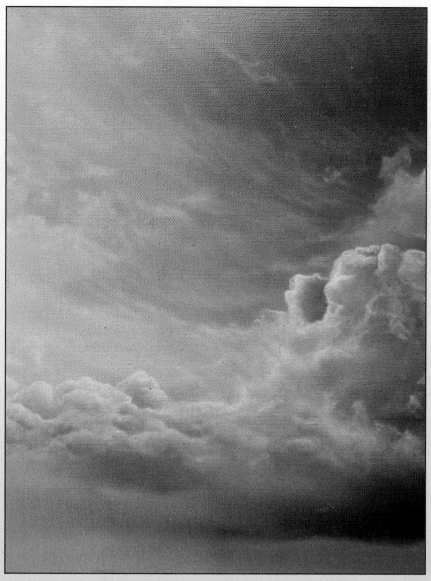

*A section of airbrush work on canvas.*

# Bases

## Textiles and leather

Textiles and leather are also suitable as bases for airbrush art.

Silk scarves, ties, jeans and T-shirts should all be washed before painting, as these textiles are usually impregnated. They might need to be ironed afterwards.

Where possible, the fabrics need to be taut when painting. For thin fabrics (e.g. T-shirts) a separator will probably be needed to prevent the colours from accidentally running into one another, and the painting on the front from showing through on the back.

Special fabric or silk paints are available for painting textiles, which usually have to be fixed using heat (hairdryer or iron).

Many manufacturers of airbrush paints offer special additives (textile medium) that make their paints adhere to fabric bases. It is important when using these additives to follow the exact usage instructions and mixing ratios.

It is advisable to work with a higher air pressure than normal in order to ensure that the paint penetrates the fabric as deeply as possible.

Where possible, the painted fabrics should be washed carefully by hand.

Special paints and/or additives are required for painting leather too. These ensure correct adhesion.

When preparing the surface, it is crucial that the material is free of

*A painted leather jacket.*

grease. For most types of leather, this is achieved by cleaning with benzine and slightly keying with 800 grain abrasive paper. A special leather primer must usually be applied before painting.

When painting leather, it is important that dubbin has not been used. Leather is a very

porous material, and dubbin is almost impossible to remove, which means that perfect adhesion of the paint to the base cannot be guaranteed.

The paint manufacturer's instructions should be followed here, too, to ensure good adhesion.

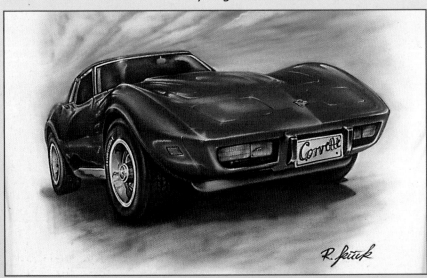
*An example of a painting on a T-shirt.*

*A selection of airbrush guns. You should try each of them out first to find the most suitable one.*

Working with an airbrush gun first requires familiarisation with the various models. The different types are subdivided as follows:

single trigger action

double trigger action

independent double trigger action.

These models can be subdivided again into those with internal or external air/paint mixing, a suction or flow system, and with or without a needle.

## Single trigger action

Models in which the trigger just controls the airflow or the amount of paint are described as having a single trigger action.

These devices come with or without a needle, usually with external air/paint mixing and suction system, with paint jar or paint bottle.

They are used for broad work, e.g. model construction or simple textile creation.

These models are usually designed as airbrush starter kits and are rarely used for detailed work.

## Double trigger action

Airbrush guns with double trigger action are suitable for beginners and for professionals alike.

These models are available with various nozzle diameters and sizes of paint canisters as suction or flow systems. The trigger serves two purposes here. It controls the proportion of air and paint, i.e. less air = less paint and more air = more paint.

## Independent double trigger action

Most of the spray guns available on the market today have an independent double trigger action.

These airbrush guns can be used for all broad and detailed work. The devices differ due to the size of the paint canister, suction or flow system, and the diameter of the nozzle.

With these airbrush guns, the trigger controls the amount of paint independently of the amount of air. This means that an artist can work with a lot of paint but without much pressure, in order to achieve a speckled effect, for example.

## Airbrush guns with special features

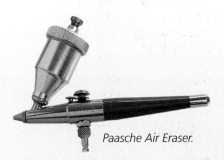

*Paasche Air Eraser.*

The Paasche Air Eraser is one of the more unusual airbrush models. It is a mini-sand jet gun that can be used as an eraser on a wide variety of bases. This model is also used for frosting glass or removing rust from small parts.

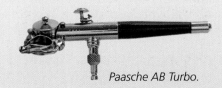

*Paasche AB Turbo.*

Another special model is the Paasche AB Turbo, whose method of action enables very fine and slow work for the creation of detailed pieces. *More about this model on pages 30 and 31.*

# Compressors

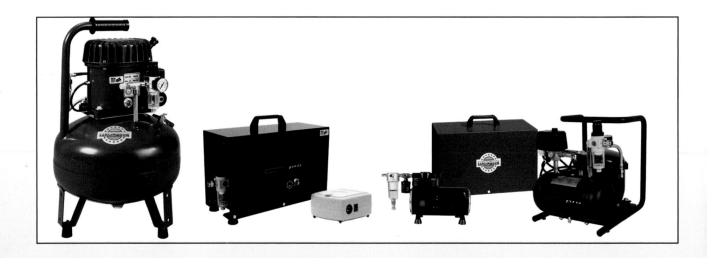

## Compressors

The most suitable compressed air sources for working with airbrush guns are compressors. These can be divided into three categories: membrane compressors, piston compressors and industrial compressors.

All the devices provide the necessary air pressure for working with a spray gun, but are significantly different in terms of their usability, noise levels and maintenance.

## Membrane compressors

These devices use a compressor and a rubber membrane to compress the air that is sucked in. The compressed air is transported directly into the air hose. This method of working generates a pulsing airflow that should be balanced out by the compensation tank and the pressure regulator.

The devices are oil- and maintenance-free, usually light and small, quiet and well priced, depending on the model.

## Airbrush pump compressors

These commonly used compressors have a drive similar to those found in refrigerators or freezers. The motors characteristically run very quietly and have a long life expectancy.

Airbrush pump compressors are mainly equipped with a pressure tank, pressure regulator, a water separator and an automatic mechanism.

Commercially, these automatic devices come with various suction levels and different-sized compressed air tanks.

The automatic mechanism ensures that the motor cuts out when a specific air pressure is reached in the pressure tank and starts up again when this air pressure falls. These compressors deliver an equal flow of air and ensure interruption-free work.

The suction power and the size of the pressure tank should be selected to meet requirements.

Pump compressors do need some maintenance, such as checking the oil level, draining the condensed water from the water separator and pressure tank, monitoring and, where necessary, cleaning or renewing the air filter.

## Industrial compressors

Another source of compressed air is the pump compressor used in industry. The way it works and the maintenance required is comparable to that of the compressors mentioned above, but even small industrial compressors have only limited use for airbrush work because of high noise levels.

These compressors provide large amounts of compressed air, such as is required when using large spray guns, for example.

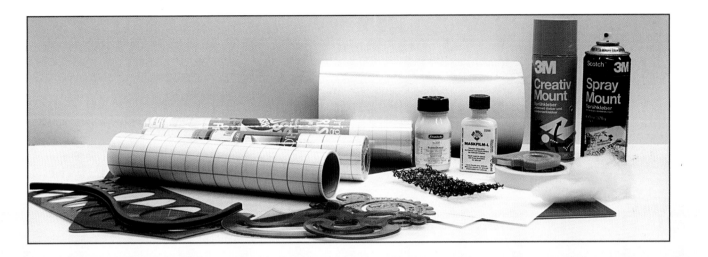

## Masks

Stencils, masks or spray limitation aids are all devices used in airbrush painting that protect areas or parts of pictures from the paint spray. A wide variety of materials or objects can be used for this, from acetate film to cellulose.

The diverse possibilities for covering an area are subdivided into firm, self-adhesive masks, loose shields and loose-weave or 'fluttering' shields.

## Firm masks

Firm masks include: adhesive tape, self-adhesive masking film, magnetic film (for metal bases), and fluid mask for the blank areas between highlights or writing. Firm masks are used to achieve very sharply defined areas within a picture.

When using self-adhesive masks, make sure that both the base and the paint are suitable for this work. Some bases, such as sketching paper, can be damaged by using self-adhesive masks, or the paint might lift off. Before starting work, a test patch should be tried.

## Loose shields

Loose shields include paper masks, acetate or transparent acetate film masks, curved rulers, circular or elliptical stencils, sheets of paper, coins, punched metal, grids, etc. Anything, in fact, that covers the work, is firm and stable, and protects areas of the picture from paint spray just by being loosely laid on it.

Loose shields placed directly on to the base can produce very hard edges. With a little space between the mask and the base, softer blend-ins can be achieved.

Loose shields from paper or film can be made into firm masks with the help of spray adhesive or adhesive mounts. In this instance, the reverse of the masks are sprayed with adhesive and allowed to stand for a few minutes before being stuck on. The remains of adhesive on the base can be carefully removed with cellulose and benzine.

Another way of fixing loose shields is to place a sheet of metal beneath the base and to use little magnets to keep the loose shields in place.

## Loose-weave masks

The materials used for loose-weave masks, such as cotton wool or cellulose, change their shape somewhat when they are sprayed (because of the air pressure), which results in soft contours. These masks are usually used for depicting clouds, or for less clear areas of the painting that are in the background.

# Aids for creating texture

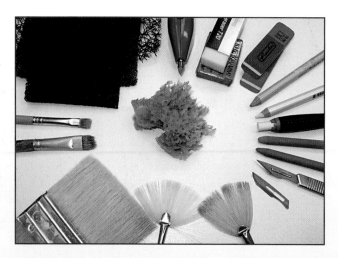

## Aids for creating texture

The possibilities for creating effective and believable textured effects with a spray gun alone are fairly limited. The airbrush technique was designed to achieve smooth fade-outs or create areas of colour without forming streaks.

Of course, any conceivable surface, such as marble, wood, stone, rust, etc. can be created using an airbrush gun, but the work and time involved is barely justifiable.

The only texture or surface feature that can be achieved quickly and exclusively using a spray gun is a porous or granular-effect surface such as sand or stone.

*The equipment necessary for speckled effects: a toothbrush, a gun with a screw-thread nozzle without a nozzle cap, and various speckling nozzles.*

To achieve these speckled effects, very little air pressure is needed when spraying; guns with screw-thread nozzles can be used without a needle or nozzle cap. Special speckle caps are also available for use with the various guns. To achieve different speckled effects, experiment with varying the pressure and distance.

*Examples of a speckled texture.*

A range of different brushes, erasers and scalpels is also useful, and considered to be standard equipment.

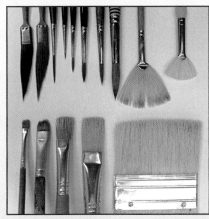

You can easily use bristle and camel-hair brushes to create a range of textures, such as hair, fur, grasses or wood.

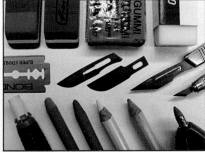

Erasers of varying hardness and in different sizes can be used to remove paint, to lighten or to work on textures.

Blades in various shapes are necessary, especially for scraping light edges or working on the texture of hair and fur.

To create other effects, such as marbling, other tools are necessary. By using various natural sponges, brushes, films, bristles, etc. lots of different textures can be created very quickly and easily. The individual results combine well with the airbrush technique.

The examples at the top of the page show how different tools can be combined. The marble surfaces were spotted and sprayed over several times with opaque and transparent paints. The veins were painted on with a red marten brush, using both the very tip as well as the wide edge of the brush. The veins and lines were reworked using the spray gun.

The procedure was similar for the pieces of wood, using a red marten, an old bristle brush and an airbrush.

Other interesting effects can be achieved using filter material (e.g. aquarium or pond filters, as well as filter mats from extractor fans). Experiment with a variety of tools, and use them to achieve different effects in your work.

*The fur in this picture was worked on with old bristle brushes, erasers, scalpels and the spray gun.*

*Different sponges can be used to create completely different textures.*

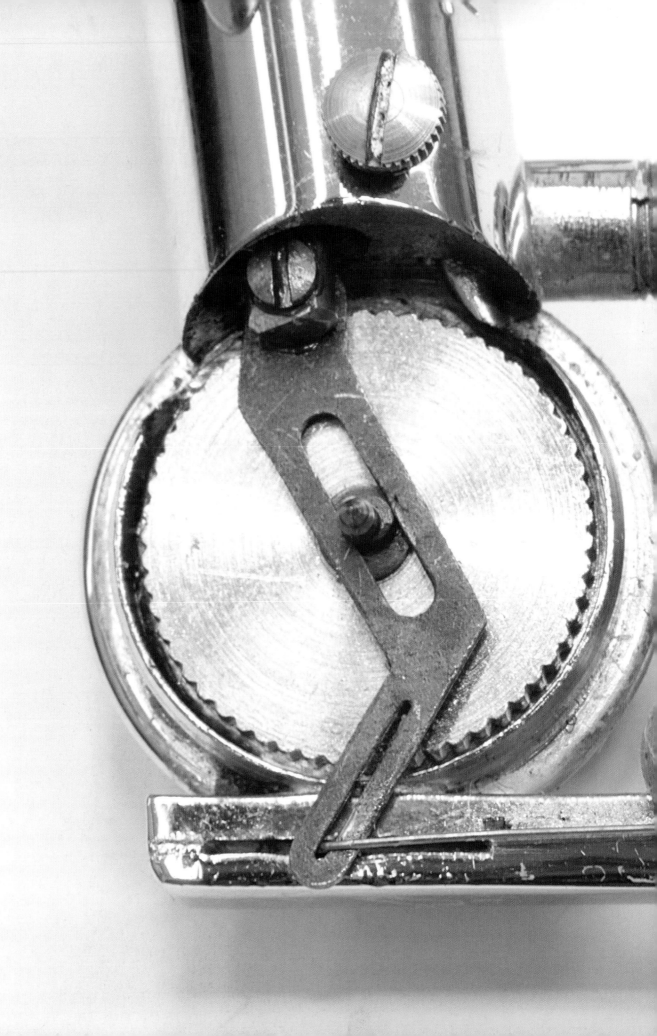

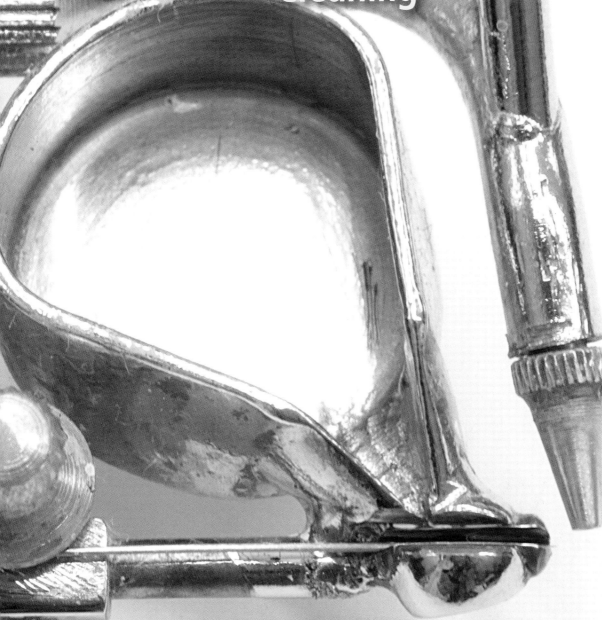

# Operation and construction

## Operation and construction

The basic action of an airbrush gun is to atomise fluid paints and media. This basic principle applies to all models, from simple atomisers to airbrushes with independent double trigger action. When painting with a spray gun, the control of the spray flow, which depends upon the viscosity of the paint, the air pressure level and the distance from the base, is crucial.

The pictures shown on this page are chosen simply to illustrate the procedure for using an airbrush gun. These models have only limited use in the areas of illustration and painting. Even for model construction or covering large areas, better models are available nowadays at reasonable prices.

The simplest airbrush device is the mouth atomiser. This model is a very simple example of how a spray gun works.

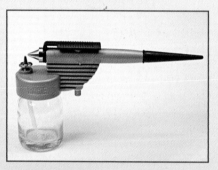

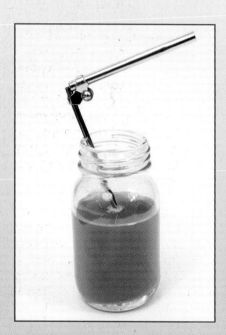

The air flowing out of the horizontal pipe creates a vacuum in the vertical pipe, causing the fluid in it to rise and be carried along and atomised by the air flowing past.

This device is only suitable for use when fixing pencil, charcoal or pastel pictures, due to the irregular atomisation.

A variant of the mouth atomiser is found in the simplest airbrush model, the spray gun. With this device, the airflow can be switched on and off with the help of a push button. The air pressure can only be adjusted at the compressed air source (propellant tank, pressure bottle or compressor).

The amount of paint that comes out is not adjustable with this device. The atomisation of the paint depends on how much it has been thinned and the air pressure set.

These models are used for large-scale work, such as creating backgrounds or for model construction.

A further development can be found in the spray gun with single trigger action (air on, air off) with a needle. This model permits regulation of the amount of paint using an adjustment screw at the end of the handle.

This method of operation, in which the amount of paint that comes out can be regulated, enables more targeted control of the paint application. For these models, too, the result depends upon the viscosity of the paint and the air pressure. They are used for model construction, creating broad areas on fabric, and filling larger areas and fade-outs in illustrations.

## Spray gun with double trigger action

This spray gun is probably the most versatile and most used model. The air and paint flow can be regulated with a trigger. This method of operation enables very precise control of the paint application.

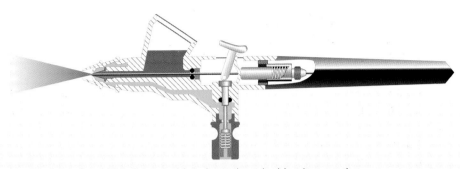

*Cross-section of an airbrush gun with independent double trigger action.*

### Spray guns with combined trigger action

Airbrush devices with combined trigger action allow the operator to control the supply of air and paint in parallel by moving the trigger. If the trigger is pressed lightly first of all, some air will flow. Once the air is flowing out, if the trigger is pressed again, paint will be added. If the trigger is pressed once more, the amount of air and paint will be increased.

This method of operation makes a lot of sense. Detailed work can be performed close to the base, by working with small amounts of paint and air pressure. More extensive paint application requires a greater distance from the base, greater amounts of paint and therefore more air pressure. These airbrush guns are suitable for all types of work.

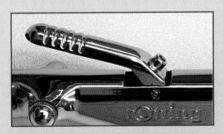

*Airbrushes with double trigger action are controlled via pressure on the trigger.*

### Spray guns with independent double trigger action

The trigger on this model controls the air supply when pressed down, from very little pressure to the highest level of pressure set on the air pressure source. Independent of this, the amount of paint that comes out is regulated by pulling back on the trigger. With these devices, artists can, for example, work with very little air pressure and a lot of paint to create various speckled effects. This method of operation also allows you to use a very small amount of paint and the highest pressure set on the compressed air source. Some practice is needed to be able to use this airbrush model.

These airbrush guns can be used with nozzle diameters of 0.15–0.80mm (as is also the case for devices with combined trigger action) in all areas of use, from the broad application of colour, model construction, illustration and painting, through to decorating fingernails.

The manufacturers of airbrush devices offer a very comprehensive range of different models commercially. The main differences are in the size and type of paint receptacle, the flow and suction systems, and the nozzles supplied, which come in socket and screw-in types and in different diameters.

When purchasing an airbrush gun, you should consider beforehand to what purpose the device is to be put, as for all the advances that have been made in the development of different airbrush guns, an 'all-singing, all-dancing' spray gun has unfortunately not yet been invented.

An important aspect of all airbrush guns is the smooth operation of all the components and the availability of spare parts. Avoid buying from cheap suppliers, buying second-hand equipment or buying copies of well-known brands.

# Operation and construction

Abner Peeler's Paasche AB Turbo Paint Distributor is a further development of the spray gun. It has a different method of operation that enables very slow and precise work on the finest of details. For a long time, this gun was thought of as the 'Rolls-Royce' of spray guns. It is made of many small individual parts that must all work together precisely.

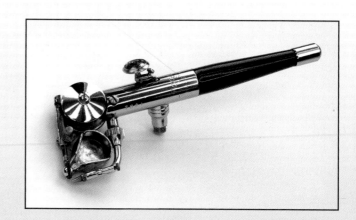

**Paasche AB Turbo**

The method of operation of this model makes it the *crème de la crème* of airbrush guns. The needle is driven by an arm from a turbine at speeds of up to 20,000rpm (depending on the air pressure). The arm that drives the needle is controlled by the trigger via an arm-connecting rod.

When the trigger is pressed, the turbine is driven by the air pressure and in turn drives the needle via the arm. The tip of the needle picks up paint as it enters the paint receptacle.

When the pressed trigger is moved backwards, the moving needle tip falls in front of the air nozzle, causing the paint on the needle tip to atomise, and it is then transferred to the base.

The way the Paasche AB Turbo works means that some fine adjustments can be made, but everything has to be very precisely coordinated. This device will need to be readjusted from time to time.

The complexity of this airbrush gun means that a precise knowledge of its construction and the way it fits together is required.

**The trigger**

The trigger has an independent double action. Pressing the trigger down controls the airflow; pulling it back regulates the amount of paint. The adjustment screw on the trigger (marked 2 on the photograph) serves to adjust the stroke length of the needle. It can also be used as a line adjustment screw. The control of the needle (amount of paint) is performed by a bolt (arm-connecting rod, 1) that is joined to the arm in the turbine housing.

**Air pressure control**

Apart from the trigger, control of the air pressure on the Paasche AB Turbo can also be achieved by other means. The air controlled by the trigger is conducted into two air feeds: one to the drive for the turbine, and the other to the nozzle pipe.

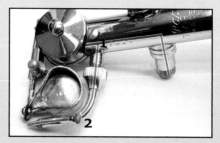

Each feed can be controlled separately by a regulating screw (1 and 2). Screw 1 reduces the air pressure to the turbine to lower its revolutions. The second screw reduces the air pressure to the nozzle to create, for example, a speckled effect.

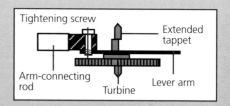

**The needle drive**

The Paasche Turbo needle is driven by the lever arm in the turbine housing. The arm is connected to the turbine by an extended tappet (pictured above), which sets it in motion. The speed at which the needle moves depends upon the revolutions per minute of the turbine; the strike length of the needle is controlled by the trigger.

1 = Needle guide screw.
2 = Paint receptacle adjustment screw.
3 = Paint receptacle.
4 = Air nozzle.
5 = Needle guide.

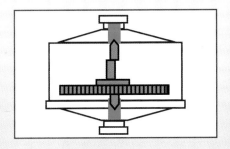

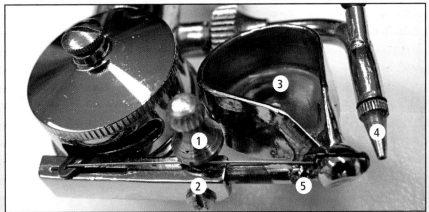

## The turbine
This is the core of the gun. If the turbine does not work correctly, the gun cannot be used precisely. The needle is driven by the turbine via a lever arm. The turbine should work smoothly when the air regulating screw is opened at a pressure of about 0.2bar. It is driven and greased by two ball-bearing screws (green). These serve to adjust the height of the turbine and the play in the bearing in order, for example, to prevent the arm from rubbing.

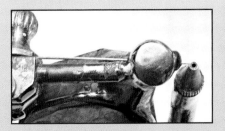

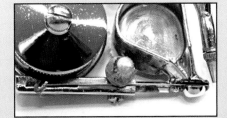

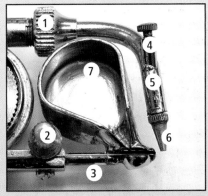

1 = Retaining nut. 2 = Needle guide screw.
3 = Needle guide. 4 = Aspiration adjustment screw.
5 = Nozzle pipe. 6 = Air nozzle. 7 = Paint receptacle.

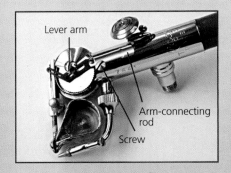

Lever arm

Arm-connecting rod

Screw

## The arm-connecting rod
This bolt is joined to the arm with a screw. Care should be taken that neither the tightening screw nor the arm are rubbing on the turbine itself.

## The needle guide
The Paasche AB Turbo needle is curved slightly upwards and downwards. It hangs in the arm and runs through a slot. To prevent the needle from vibrating at the top when moving, slight pressure is exerted from above by the needle guide screw. The needle is guided into a hard metal insert at the paint receptacle.

Care must be taken to ensure that the needle moves evenly and is centred in front of the air nozzle.

## The paint receptacle
By turning the paint receptacle, the height of the needle can be adjusted to the centre of the air nozzle. The distance from the paint cup to the air nozzle can be altered using the paint receptacle adjustment screw.

## The nozzle pipe
The air reaches the air nozzle via the nozzle pipe and the resultant air pressure can be reduced using the aspiration adjustment screw. The distance to the needle tip and the paint receptacle can be altered by means of the nozzle pipe. The nozzle pipe can also be used to centre the nozzle and the needle.

In order to adjust the nozzle pipe, the retaining nut must first be loosened.

# The individual parts

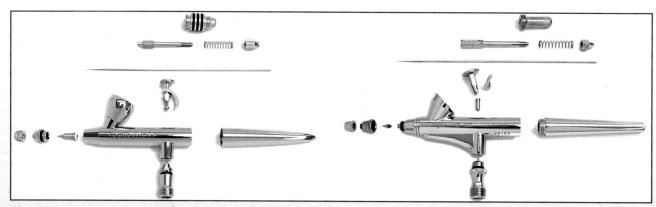

The airbrush guns shown above are the most commonly used types. Most other airbrush guns are similar in construction to these devices.

## The needle cap

This cap comes in different types: the closed cap, the punch or jetstream cap, and the crown cap. The cap is designed to protect the needle tip of the airbrush gun from damage. The needle cap need not be used if the spray gun is handled carefully. Not using the cap has the advantage that the needle tip can be cleaned of paint deposits more quickly while working.

Some airbrush models are offered as standard without this cap, whereas with other models the needle cap is a part of the nozzle cap and cannot therefore be removed.

A damaged or dirty cap often leads to a build-up of paint deposits during working (particularly with large areas), which then causes blobs to appear.

## The nozzle cap

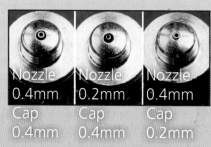

This part of the airbrush gun is also known as an air or nozzle head, and its main function is to conduct the airflow. The compressed air at the nozzle is passed through the tiny hole at the front of the cap, which takes up and atomises the paint escaping from the nozzle.

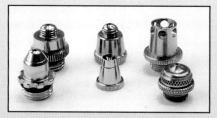

Nozzle 0.4mm / Nozzle 0.2mm / Nozzle 0.4mm
Cap 0.4mm / Cap 0.4mm / Cap 0.2mm

This tiny hole needs to be exactly right for the diameter of the nozzle. If the hole is too big, the paint will be agitated too strongly. If the hole is too small or the nozzle too large, there will be insufficient air, resulting in speckling or complete failure.

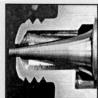

The pictures show a nozzle cap after a break (without a needle cap), where the surface around the hole was flattened out. The cross-section shows how the distance from the hole to the nozzle varies. This results in a slanting flow of escaping air that has a negative effect on the spray pattern.

Damage to or dirtying of the cap, particularly the hole, or a poorly made component, can ruin the spray pattern.

Socket nozzle caps must be firmly in place, as the cap presses the nozzle of the airbrush gun against the sealing surface of the body of the gun.

The cap, particularly the hole, should be thoroughly cleaned from time to time with a small paintbrush or dental brush.

## The nozzle

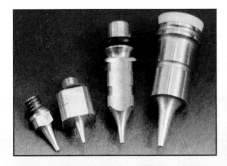

Nozzles for the airbrush gun are divided into two groups: screw-in or socket. For socket nozzles, an intact sealing ring is required to prevent the paint from running out and compressed air from entering the paint feed. These seals should be checked regularly and changed when worn out.

Screw-in nozzles are generally made without an additional seal. This assumes, however, that the sealing surface on the body of the gun and the thread of the nozzle have been precision-tooled. Some of the cheaper airbrush models need sealant or an O-ring to seal the screw-in nozzle fully.

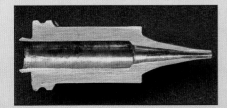

Both types of nozzle have their advantages and disadvantages. Socket nozzles are usually precision-made from soft metal alloy, i.e. the surfaces of the nozzles are smoother, so that less paint residue is deposited on them and the nozzles are easier to clean. However, the soft material means that it wears out quicker and is a little less robust.

*A crack in the nozzle tip is usually visible only with a magnifying glass, which should form part of your standard equipment.*

It is therefore vital to proceed very carefully. A little too much pressure when using the needle can result in a crack in the nozzle tip and make the nozzle unusable. A faulty seal or a damaged nozzle tip is often the reason for a poor spray pattern, or air bubbles in the paint receptacle.

Screw-in nozzles are usually made from more robust material, as the thread requires stability. Due to the harder material, the holes in screw-in nozzles are often not as smooth, causing paint deposits to collect in the surface grooves in the nozzle hole.

Cleaning the nozzle therefore involves a little more effort. Another aspect that should be taken into consideration is the fine thread. The lightness of the material means that there is a danger of the nozzle cracking when it is put together or taken apart. A very gentle touch is required when doing this.

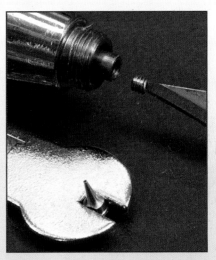

If, despite being careful, the nozzle should break, the threaded piece can often be turned using a pointed scalpel. Take care, however, to avoid damaging the sealing surface on the body of the gun.

If air bubbles appear in the paint receptacle after taking the nozzle apart or reassembling it, a leak at the nozzle thread is generally the cause. This can be rectified by either carefully tightening the nozzle or using sealant or a sealing ring.

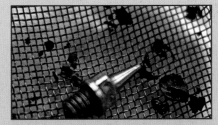

*Poor quality paint is the cause of most blockages. The picture shows paint blobs remaining in a large strainer in relation to a 0.2mm diameter nozzle.*

# The individual parts

### The needle

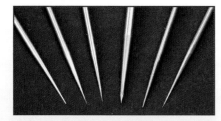

The needles for various airbrush guns are made to match the corresponding nozzle diameter. The taper of the tip and the diameter of the various needles can therefore vary.

Top: a needle with a very smooth polished surface. Middle: a standard needle. Bottom: an example with a bent tip.

An important aspect is the make-up of the surface of the needle tip. The smoother it is, the less paint deposits will adhere to it. A bent needle tip will 'swirl' the flow of paint making the spray pattern inaccurate, and paint particles will collect very quickly on the tip of the needle.

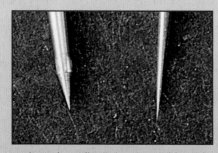

A slanted needle tip is more stable and is usually used with larger nozzles.

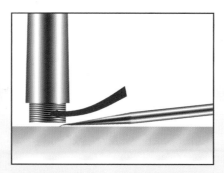

A slightly bent needle tip can be straightened using a glass plate (or similar smooth surface) and a stable, hard object, such as the handle of the airbrush gun. Lay the bent needle tip flat on to the base and press straight down on to it with the handle. The needle should be turned slightly all the time. The very tip of the needle can also be worked on using fine abrasive paper, but not including the part of the needle that sits in the nozzle. If this part loses its roundness as a result of sanding, the needle will not seal properly in the nozzle.

A small sanding machine with revolution control, wet abrasive paper and polishing paste is available for repairing and polishing needles. When using a sanding machine, it is important that the needle is held securely before the machine is switched on. Otherwise, the needle may snap, rotate and cause serious injury when the machine is switched on.

### The trigger

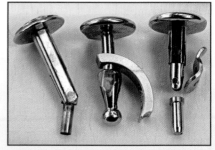

Some different triggers. Left: with moving air piston (on this model, the trigger is fixed to the needle clamp feed). Middle: with attached trigger and ball. Right: with loose trigger and air valve piston.

The trigger for the various airbrush types controls the air pressure and the amount of paint. For some models, the trigger controls the air valve by means of an air valve piston or a ball-shaped end. On most airbrush guns, the trigger needs to be loose to regulate the paint.

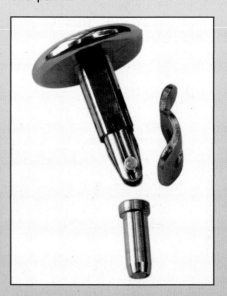

These movable pieces should be cleaned as necessary and made free of grease, especially when the air valve piston starts to stick and the air supply is no longer controllable.

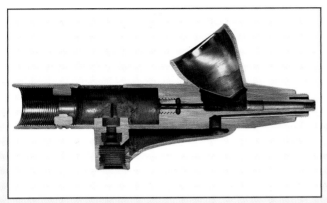
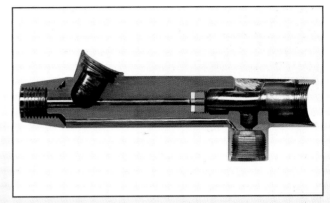

*A cross-section of the airbrush gun body. The paint feed, air feed and the seals inside the gun can be seen clearly. In the model on the left, rubber seals (grey) are built in; the model on the right has a Teflon seal (white). Current models come almost exclusively with Teflon seals.*

## The body of the gun

The body of the gun is, along with the handle, the part that experiences the least wear and tear and requires the least maintenance, other than cleaning. Most of the components of the airbrush gun, including the body of the gun, are chrome- or nickel-plated. With continuous use, this protective layer will wear off in places, but this will not affect its action.

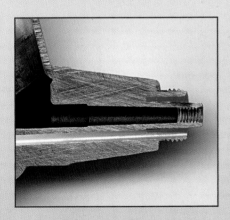

The paint-conducting areas of the body of the gun (coloured red in the photograph above) should be regularly freed of paint deposits using a dental brush or microbrush and a suitable cleaner. For airbrush models with screw-in nozzles, it is recommended that these are also removed if the cleaning is performed in an ultrasonic device.

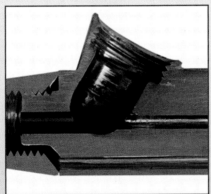

The bodies of guns for airbrush models with screw-in nozzles are generally easier to clean. The paint feed is often significantly shorter and easier to reach.

The air feed (coloured blue in the photograph above) generally needs no special care or maintenance.

## The needle packing

The needle packing or seals in the body of the gun ensure that no paint penetrates the back of the body of the gun. These seals must be changed occasionally or

the needle packing screw must be tightened. These screws can become loose after cleaning the body of the gun in an ultrasonic cleaner.

Paint deposits can collect on the needle packing and cause the needle to stick. If this happens, the body of the gun should be taken apart and cleaned carefully.

The needle of the airbrush gun should not be removed if the paint container is full, otherwise the paint might run into the back of the gun, causing moving parts such as the trigger mechanism, the air valve piston or the needle clamp unit to stick.

# The individual parts

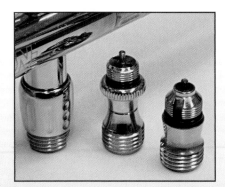

*Various valve units. The one on the left has an additional pressure regulator that enables the pressure to be easily set while working.*

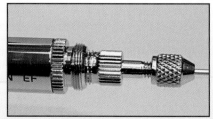

*A needle clamp unit for the IWATA Micron. With this model, the spring tension can be adjusted at the needle adjusting sleeve.*

## The valve unit

This part serves to connect to the compressed air source and controls the air supply via the trigger. This unit can sometimes stick, and will then need to be greased. With older airbrush guns, the sealing rings for this component can wear out. If this happens, the valve unit should be changed as a complete unit.

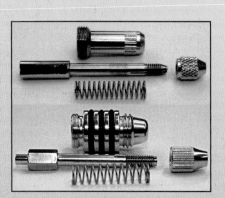

## The needle clamp unit

The needle clamp unit serves to return the needle to its starting position, in which it closes the nozzle after having been moved backwards by the trigger.

This part of the airbrush gun is made of several components: needle adjusting sleeve, needle clamp feed, needle clamp screw, and needle return spring.

The needle clamp unit is constructed very similarly for different airbrush models. Some offer the option of adjusting the pressure of the needle return spring by altering the needle adjusting sleeve as required. The resistance of the spring is an important aspect for many users when working with an airbrush gun. The movable parts of this unit should be greased regularly.

## The handle

The airbrush gun handle can vary considerably from model to model. Essentially, the handle is designed to give a better grip on the airbrush gun when working and also to protect the needle clamp unit. The different types of gun have varying weights, which means that a heavier handle can balance out the top-heaviness of an airbrush gun with a large paint reservoir, thereby ensuring that the airbrush gun sits better in the hand and, as a consequence, is also comfortable to use.

Also worthy of mention is that some models have a paint regulator screw in the handle. This adjustment screw can be turned up or down to move the needle backwards, limiting the maximum amount of paint that comes out.

An extension of the paint regulator screw is the so-called Quick-Fix, a device that, at the touch of a button, releases or sets the adjusted position, similar to the action of a ballpoint pen.

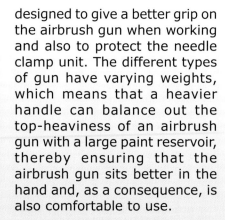

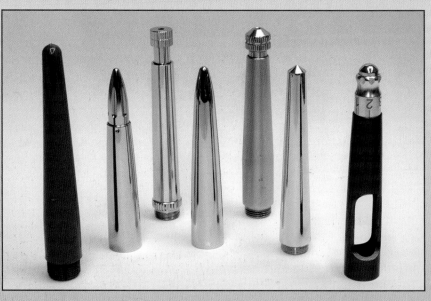

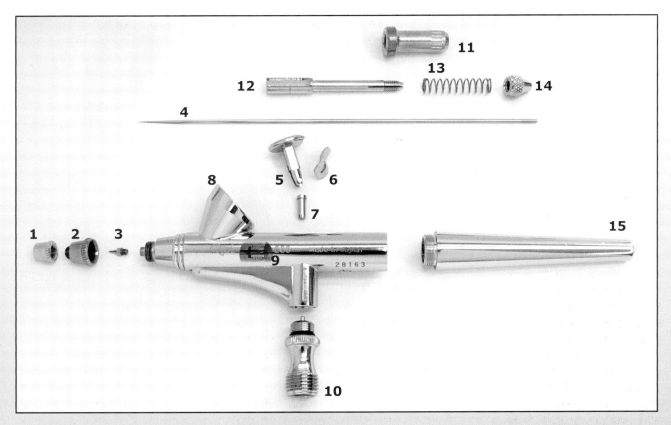

1 = Needle cap.
2 = Nozzle cap.
3 = Nozzle.
4 = Needle.
5 = Trigger.

6 = Pressure lever.
7 = Air valve piston.
8 = Body of the gun.
9 = Needle seal.
10 = Valve unit.

11 = Needle adjusting sleeve.
12 = Needle clamp spring.
13 = Needle return spring.
14 = Needle clamp screw.
15 = Handle.

Good quality airbrush guns can be obtained from the well-known manufacturers, such as Badger, DeVilbiss, Efbe, Fischer, Gabbert, Harder & Steenbeck, Hohlbein, Iwata, Olympos, Paasche, Rich (RichPen), Rotring, etc. Each manufacturer offers models for different users, from beginners to professionals. (This does not include airbrush devices such as the atomiser, or a gun on which the amount of paint has to be set in advance.)

The better models in terms of quality with double and independent double trigger action should not cause any problems if used properly.

Most problems that occur when working with the airbrush gun are caused by lumpy paint, poor cleaning and insufficient maintenance. Maintenance and repair work can also be performed by many retailers or by the manufacturer.

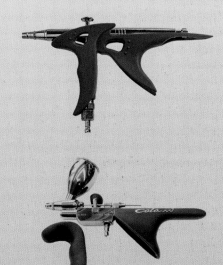

*Handles like those on the models shown on the right require the operating finger to be in a relatively upright position, which means that clenched control of the trigger is less likely. Working on a vertical surface (e.g. an easel) is recommended with these types of handles.*

# Cleaning

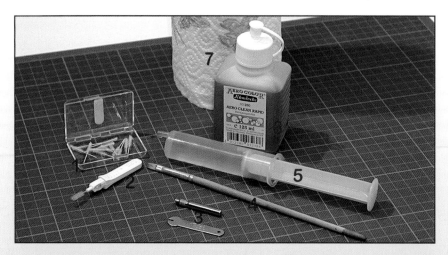

## Materials for cleaning

**1** = Needle cap.
**2** = Dental brush with holder.
**3** = Nozzle wrench.
**4** = Small bristle brush.
**5** = Water.
**6** = Airbrush cleaner.
**7** = Kitchen roll.

Most users recognise that to achieve a clean, fine spray pattern, a well-functioning gun is needed.

### Routine cleaning

1. The paint reservoir is filled with water and the air vent is closed (close the needle cap).*

2. The trigger is pressed down and carefully pulled back. This causes the air to be pushed through the paint feed into the paint reservoir and the contents of the paint receptacle will begin to bubble. Fairly big particles of paint or deposits can come loose when doing this and are flushed out with the water.

3. Finally, the paint reservoir is filled with three to four drops of cleaner and water and washed out with a small bristle brush. This mixture is also frothed up again, and then emptied out.

4. The whole process is repeated two to three times before rinsing the gun with plain water.

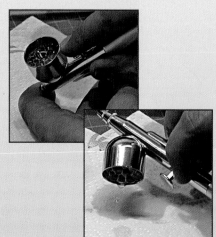

5. Finally, the needle is removed and cleaned with a soft cloth and some cleaner.

When inserting the needle, take great care not to damage the tip. Guide the needle slowly as far as the stop, and tighten the retaining screw.

*\* A tip for owners of guns with a crown or punch cap: prevent air from escaping using a cap from a replacement needle pack or from the top of a felt-tip pen.*

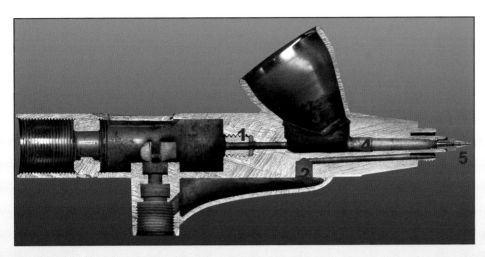

**1** = Needle seal.
**2** = Air feed.
**3** = Paint reservoir.
**4** = Paint feed.
**5** = Nozzle.

The picture above shows the areas that cannot be reached with a standard clean.

The most important area is the paint feed, which has a relatively rough surface. The nozzle can also have some rough areas in the hole as a result of the manufacturing process. The paint sticks particularly firmly to

these points and can be removed only with some effort.

Another area is the hole in the mechanism in which the needle seal sits. Paint deposits gradually form in this part of the gun and can cause the needle to stick in the region of the seal.

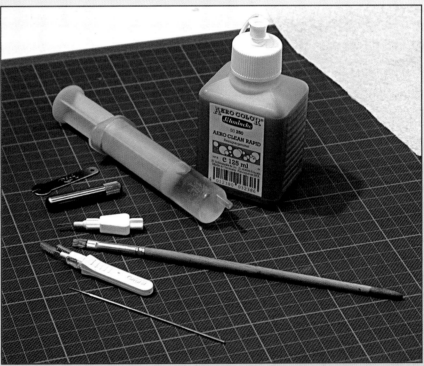

**Spring clean**

Some additional tools are needed for a thorough clean of the airbrush gun.

Apart from the usual items, such as cleaner, water and a brush, make sure you have to hand a nozzle-cleaning needle, an old airbrush needle, a suitable nozzle wrench (for airbrush guns with screw-in nozzle) and a suitable dental brush.

Nozzle-cleaning needles are available from specialist retailers, but the right cleaning needle for the corresponding nozzle needs to be selected. The small brushes can also be found at specialist retailers or chemists.

# Cleaning

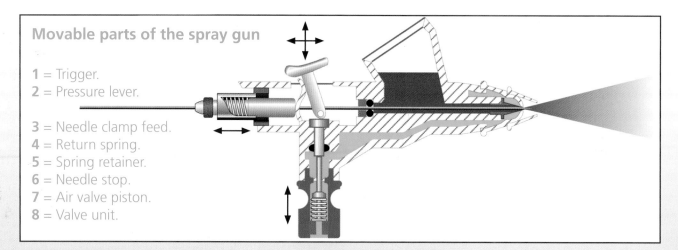

**Movable parts of the spray gun**

1 = Trigger.
2 = Pressure lever.

3 = Needle clamp feed.
4 = Return spring.
5 = Spring retainer.
6 = Needle stop.
7 = Air valve piston.
8 = Valve unit.

1. Before performing a thorough clean, perform the routine clean outlined on the previous page. Once this has been done, the gun can be dismantled as follows:
   - unscrew the handle and remove the needle
   - unscrew the needle and nozzle caps
   - remove the nozzle (very carefully).
2. Clean the needle with a soft cloth and some cleaner.
3. Remove paint deposits from the nozzle and needle caps with a small bristle brush, cleaner and some water.
4. Wash out the paint reservoir again using a small bristle brush and a drop of cleaner.

**Bristle brush**

5. Brush out the paint feed from the container outwards in both directions with a suitable dental brush and cleaner.

**Dental brush**

6. Clean the paint feed with the brush via the screw-thread hole of the nozzle.
7. Fill the gun with water and allow the water to run out of the paint feed by holding the body of the gun at an angle.

**Dental brush**

8. Repeat the procedure with the dental brush as often as required until there are no more paint particles in the water.

**Needle**

9. Place a needle (an old one if possible) into the gun with the needle tip to the back until the end reaches the paint container. Then add some cleaner to the paint container (closing the paint feed at the front with your finger) and move the needle back and forth around the area of the needle seal. This will loosen any paint deposits around the needle seal. Then, rinse out thoroughly with water again.
10. Cleaning the nozzle should first be done with the bristle brush and some cleaner. Then work over it with a suitable cleaning needle. Be aware that these needles come in very different shapes. The three- or four-sided cleaning needles should be inserted very gently into the nozzle and turned, as the edges could otherwise damage the nozzle hole.

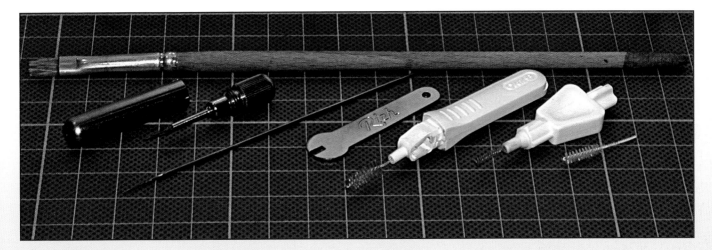

11. When all the individual pieces have been cleaned, the gun can then be put back together. Take special care when fitting the nozzle, as it may crack if too much pressure is exerted when tightening it.

Before replacing the needle, the movable parts of the mechanism can be removed and cleaned with a dry cloth. Normally, the mechanism should not require a lot of cleaning. The movable parts should be lubricated with resin-free oil (e.g. gun or sewing machine oil) or grease (e.g. Vaseline) before fitting.

To remove the air valve piston (7) (for airbrush guns, such as IWATA and RichPen), the valve unit must first be dismantled. It can be unscrewed as a complete unit using pliers.

For other airbrush guns, the air valve piston is connected to the trigger or is located directly in the valve unit.

Thorough cleaning of these parts is usually only necessary if, for example, the needle seal is faulty or not properly secured, in which case paint can get into the mechanism and cause the movable parts to stick.

This can also happen if the needle is removed while the paint receptacle is full. The paint will then flow all around the back of the gun and can, if it dries, gum up the mechanism.

*Another option for cleaning is a good ultrasonic cleaner. Airbrush guns need to be dismantled for cleaning with this process, too, and then dried and greased before reassembly. These appliances are very convenient to use, but also very expensive to buy.*

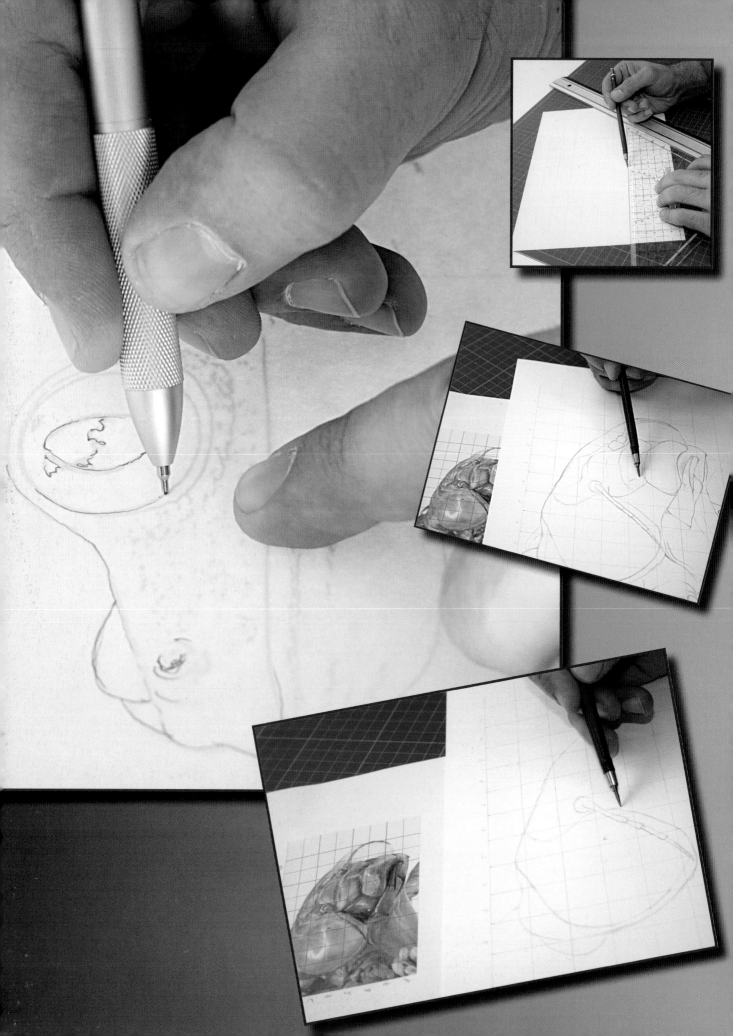

# ENLARGING
## and transferring

# Enlarging photographs for copying

A task that constantly presents itself to artists and illustrators is that of enlarging pictures or photographs for copying. Of course, freehand drawing is always an option, but it requires good artistic skill. Even experienced artists have to correct their drawings in places. In particular, if exact proportions need to be transferred from a photograph, a lot of time can be saved by using the right tools.

Some of the tools for simplifying true-to-life drawings, such as the 'camera lucida', were being used back in the 1800s. Nowadays, technical equipment, such as photocopiers, projectors and computers connected to scanners and printers, offer numerous options for exact enlargement of photographs, drawings, logos or script. Another enlargement technique frequently used by many photo-realists is the grid method.

## Grid enlargement

This method of enlarging is very simple and has some advantages over other methods. Copies can be made in any format, from reduced to oversized, such as when painting a building.

*A macro photograph of the head of a dragonfly larva serves as a model.*

The first step consists of drawing a grid over the model, preferably in 1 × 1cm (½ × ½in) squares. Depending on the design, a rough or fine grid can be drawn.

To preserve the original picture, the grid can be drawn on transparent film and placed over the photograph. This is a good option when drawing pictures from books or commissioned photographs, for example.

Next, an enlarged grid is transferred on to drawing paper. It is best to work here with a set square and ruler so as to draw the lines of the grid swiftly and precisely using parallel transfer.

For this, it is important to use a sharp, soft pencil (HB or B) with as little pressure as possible on the paper. That way, the thin lines can easily be erased later with a soft eraser (such as an eraser made from modelling clay).

A common mistake is to use a pencil that is too hard. Because such pencil lines are often not very easy to see, there is a tendency to apply more pressure when drawing, with the result that the strokes are difficult to remove or leave indentations in the paper.

In the following step, the initial contours are drawn using the intersections with the grid lines as a guide.

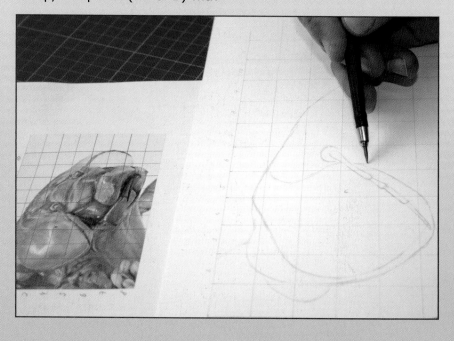

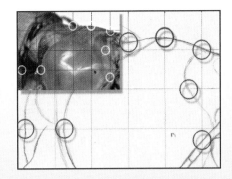

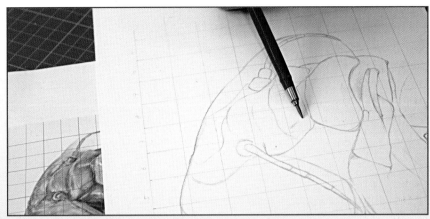

To work out these intersections, a reasonable sense of proportion is required. The simplest way to do this is to divide the length of the grid line in half visually, so that an estimate can be made of where the intersection occurs. Beginners might find it useful to measure out the individual intersections. More complex designs might require a finer grid.

This may seem like a huge amount of work in comparison with other enlargement methods, but it has the advantage that the picture is studied very closely, making the subsequent transposition much easier.

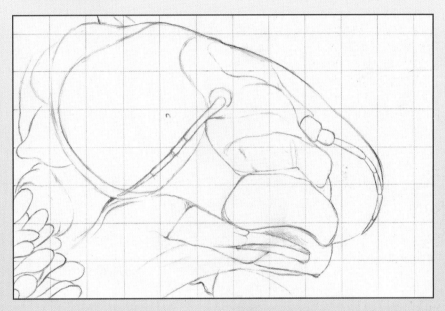

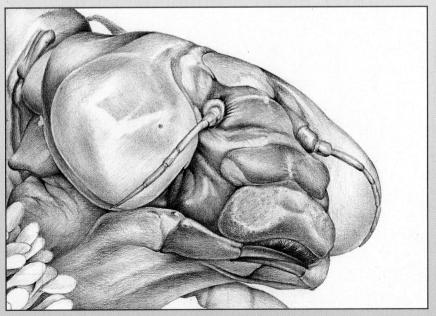

Because every segment of the picture is examined thoroughly, even absolute beginners can perform the transposition accurately.

*Working in more detail on the contour drawing is not necessary for an airbrush illustration, but it is a useful exercise for inexperienced artists.*

# Projectors

Another option for enlarging photographs to any size is to use a projector. There are various sorts, including slide projectors, episcopes, overhead projectors and video projectors.
This equipment is very easy to use and operate, and saves time. However, some things need to be taken into consideration.

For an easily recognisable reproduction of the image, a fairly dark room is needed. As a rule, the smaller the light source of the projector, the darker the room needs to be. The light source of the projector also affects the heat that is generated: a photograph can expand and distort with increasing heat.

## Projectors

Different projectors are suitable for different types of pictures. Slide and overhead projectors require light-permeable pictures/photographs. Pictures that are taken from photographs or printed images from books or magazines must first be made into the required format. For use with a slide projector, the picture must be photographed with a slide film and then developed.

suitable transparent sheet that can be used in a copier, or using a computer with the relevant equipment to scan and print the transparency.

Another possibility is to transfer the picture on to a transparency using a marker pen. With this method, remember that a 0.5mm or 1mm thick line on a transparency will come up much thicker when enlarged and will therefore be less accurate.

as the maximum supporting surface of the projector. Most of these appliances are limited to subjects in a format of 11 x 11cm (4¼ × 4¼in) or 15 × 15cm (6 × 6in).

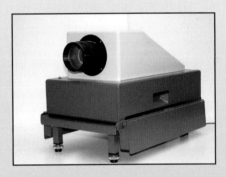

*An episcope with a very good projection and a large supporting surface. The metal housing means that this appliance weighs approximately 20kg (44lb).*

This appliance varies in quality from a children's toy to a good professional model, usually with a metal finish. Some of these models are supplied with a table or wall mounting, which makes them very convenient to use.

The heat that comes off some appliances with strong light sources is very high, and the built-in fans are often insufficient, with the result that the picture quickly expands and must therefore be drawn very quickly.

*Slide and overhead projectors are suitable for enlarging transparent pictures.*

## Overhead projectors

Opaque pictures that need to be enlarged using an overhead projector must be made into a transparency. There are many options for doing this, such as copying the picture on to a

### Episcopes/paxiscopes

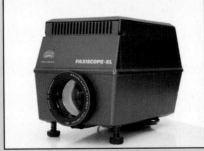

An option for enlarging paper artwork is the episcope. This appliance can be used to enlarge photographs, drawings and some three-dimensional objects.

Elaborate preparation of the subject is often not needed with these appliances, so long as the size of the subject is the same

## Video projectors

These projectors are highly suitable for digital photographs, drawings, logos and script. The light source and picture quality of these appliances are usually very high, which means that the room does not need to be very dark. Most of the new projectors offer a full range of connection options, such as computer, video and digital camera (limited).

The quality of the enlargement of the subject depends upon the resolution of the digital picture and the power of the appliance.

A significant advantage of this projector is that a distorted (trapezium-shaped) projection can be corrected.

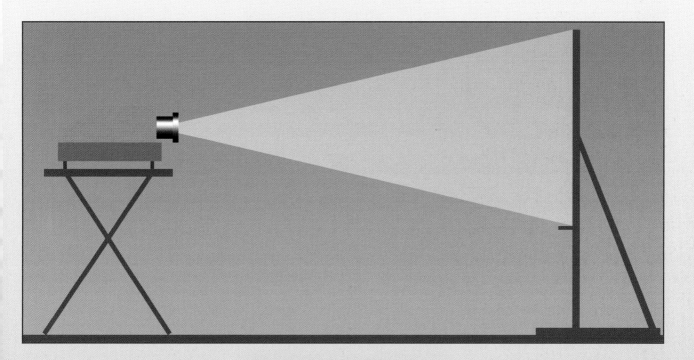

To avoid distortion of the image, the projector should stand parallel to the projection surface. It can be helpful to use a ruler to check that the outside edges of the projection are parallel.

Projecting on to curved surfaces is not recommended.

*The example on the right shows a distorted projection due to incorrect alignment of the projector.*

Depending on the appliance used, the work may need to be done very quickly. It is worth sketching the shapes and proportions first and then adding the less relevant detail.

Appliances with low heat generation allow you more time for copying the subject, which is a big advantage for very detailed designs.

# Copiers and computers

A further option for making enlargements is to use a photocopier and computer (with the relevant additional equipment).

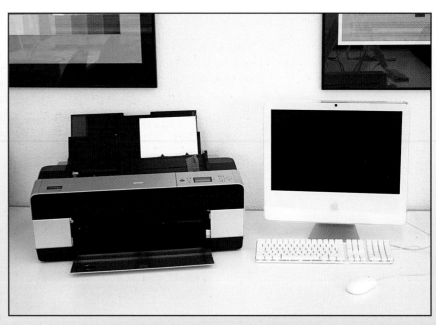

*The options offered by a well-equipped computer are so vast that some training time is necessary.*

## Photocopiers

Subjects such as drawings, photographs, logos or pieces of script can be enlarged or reduced to almost any size using a photocopier. These copies can then easily be transferred to an appropriate base. Some copy shops offer enlargements up to A2 or A1 size. Most appliances are limited to a maximum size of A3, which means that a larger format has to be divided into several sections for enlargement. These individual pieces must then be fitted together exactly. A disadvantage of this is that sometimes several copies have to be made, which always results in a significant loss of quality of the subject.

Low contrast, very light or very dark images are often unsuitable for enlarging on a photocopier.

## Computers

Personal computers (PCs), which can be found in virtually every home, offer a whole range of possibilities for enlarging, reducing and reproducing pictures or other subject material, although additional equipment is necessary for inputting the image and printing the copies. For digitising, a scanner or digital camera is needed, and a printer is required for the print-out. Should further processing or preparation of the digital data be needed, additional programs are often available.

By using the relevant hardware and software (and having the required experience), results can be achieved that will make the job of enlarging much easier. Data prepared on the PC can be printed out at the right resolution and with the right equipment (such as a large-scale printer) in the desired size and number.

Even a normal A4 printer is capable of printing out individual parts of the image in large format. The quality is usually much better than with a photocopier, but always depends upon the settings that the PC, scanner, printer and software offer.

There is also the option of drawing an outline sketch on the PC and cutting this out directly as a mask with the help of a cutting plotter. This solution is useful for text and logos that have a very definite outer edge.

In order to be able to make good use of all the advantages offered by computers, a certain amount of training is required.

## Options for transferring

The sketching for airbrush work must be as accurate and clean as possible. The strokes should be very fine, i.e. without pressing hard with the point of the pencil and not going over lines several times or correcting them. When transferring using copier paper, printer paper or vellum, avoid pressing too firmly with a hard pencil when going over the lines, so that there are no visible pressure points left on the base.

Also, making the copy or print-out too black can lead to inaccurate results. To prevent the copier paper (printer paper or vellum) from slipping, it can be fixed to the base with adhesive tape. Make sure, however, that the sheet can be lifted away from the base for checking purposes.

### Freehand drawing
The simplest and least complicated option for an experienced artist is the freehand transfer of the most important parts of the design. Care should be taken that not too much erasing is done on the airbrush base (sketching paper, card or canvas), as an eraser can alter the surface characteristics.

### Copier or printer paper
The reverse of the copier paper (or printer paper) is evenly coloured over with pencil or

coloured chalk. Next, the sheet is placed over the airbrush base and attached using strips of adhesive tape. Then all the

necessary contours etc. can be pressed through with a sharp, hard pencil. Alternatively, graphite paper can be used for tracing.
N.B. DO NOT USE CARBON PAPER. Strokes created with carbon or carbon copy paper cannot afterwards be removed with an eraser.

### Vellum
A similar approach to transferring using copier paper is used with tracing paper. The tracing paper is placed on the original, the important contours are traced, and then the reverse is coloured black with pencil. Next, the prepared vellum is placed on to the base and the contours are traced again.

### Light table
To transfer a drawing or sketch on to airbrush paper, a lightbox or light table can be used. For this method of transfer, the airbrush paper is placed on the sketch or drawing and illuminated from below on the light table. It can then be very easily transferred to the airbrush paper. A window can be used as an alternative in good daylight.

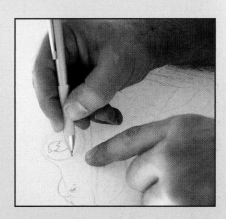

This option is not suitable for drawing board, and has only limited potential for canvas.

### Perforation
This involves perforating along the required contours of the sketch or drawing (either on the original or on a copy) using a perforating wheel or needle. This perforated drawing is then fixed to the base and dabbed with a little linen bag filled with carbon or graphite dust.

# COLOURS

# Primary colours and colour mixing

A challenge that frequently faces many painters or illustrators is knowing about the different shades of paint and how to mix them. Often, when photographs are reproduced, the artist is continually trying to replicate the colours as accurately as possible.

The subject covers a broad spectrum, and the advice given here for airbrush art and illustration is just a starting point.

In general, all the main colours can be made from mixing the three primary colours, which are cyan blue, magenta red and yellow. These colours cannot themselves be made, but form the basis for all other colours. They are also the colours that are used in printing, such as in this book. For four-colour printing, black is always used as well. These colours should be recognised by most people as they are also used by inkjet printers.

*Full-tones of the print colours: cyan blue, magenta red, yellow and black.*

The many books available about colour theory have usually been printed using these same colours – cyan, magenta, yellow and black – unless they contain other colour descriptions of the primary colours.

The descriptions, or names, of colours and their interpretation provide a further hurdle for the artist or illustrator to overcome. The usual names given to colours, such as red, blue or green, are imprecise. If someone talks of green, which green do they mean? Grass green, moss green, olive green or forest green? And of what intensity? In simple terms, green would be a mix of the primary colours yellow and cyan blue in equal proportions. In terms of print colours, many factors pertaining to colour are controlled to some extent in the same way. However, for artists' colours, there are some aspects that should be taken into consideration.

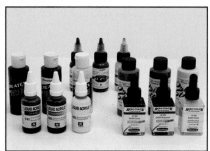

The names of the individual primary colours are not always the same, depending on the supplier. Another big difference is in the pigment concentrations of the various colours. Other differences occur between transparent and opaque colours, and in how intensely these colours are applied. The number of colour descriptions is increasing as a result of terms such as opaque, semi-opaque, transparent and semi-transparent. With the right degree of thinning, or if sprayed in thin layers, every colour is transparent. Opaque colours contain white or have very high levels of pigment.

Because of such differences, it is not possible to give precise instructions on exact colour

*The differences in colour obtained when mixing different versions of the primary colours magenta red and yellow in a ratio of 1:1. Top left: Vallejo. Top middle: Etac. Top right: Schminke. Below left: Createx. Below middle: Hansa. Below right: print colour.*

mixing. The most effective method of learning about colours and becoming familiar with colour mixing is to keep practising and experimenting.

It is a good idea to practise some colour mixes with a favourite colour system and draw up some mixing tables to get a feel for these colours.

# Primary colours and colour mixing

Practise with primary colours: colour grading and fade-outs. If colour fade-outs in the primary colours are placed against one another, the overlapping of the colours gives a full spectrum of the blended colour.

This mixing, in which transparent colours are overlapped, is called optical colour mixing. If the primary colours are mixed in the gun or on the palette, this mixing is called physical mixing.

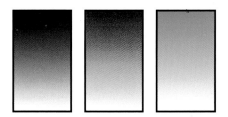

Mixing the primary colours in a ratio of 1:1 should then give the secondary colours blue, red and green.

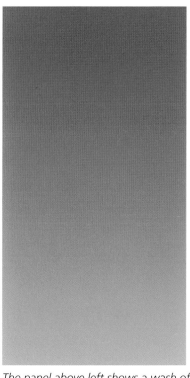

*The panel above left shows a wash of five parts yellow mixed with one part cyan blue; the panel above right shows a wash of the colour brilliant green (in printing, too, these colours consist of yellow and cyan). For an exact reproduction, a special colour must be printed. The difference between the colouring can be clearly seen in these examples.*

If a green mixed from cyan and yellow is compared with a 'ready-made' shade of green, such as 'brilliant green' by Schmincke, there is a significant difference. The ready-made 'brilliant green' colour consists of only green pigments. The colour green mixed from cyan and yellow offers a wider spectrum of shades of green, from yellow-green to blue-green. If, for example, five parts yellow are mixed with one part cyan, a yellow-green is formed. If several layers are overlapped, the darker pigment (cyan) deepens and the green is much darker.

With some knowledge and experience, virtually any colour can be made from the three primary colours. Nevertheless, it should be borne in mind that

many shades of colour are much easier to mix with the help of secondary or tertiary colours.

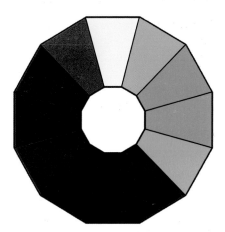

*Primary colours: yellow, cyan blue and magenta red. Secondary colours: red, green and dark blue. Tertiary colours: red/orange, orange, blue/violet, violet, yellow/green and blue/green.*

# Primary colours and colour mixing

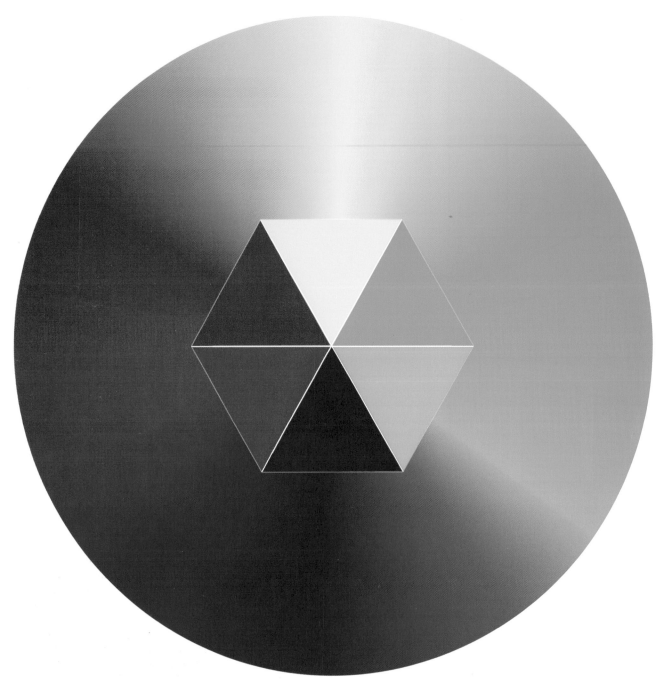

Another exercise to try is spraying a colour wheel. It is best initially to spray a colour wheel in the colour ratio of 1:1 mixed in the gun (physical mixing). That way, as well as the primary colours, the secondary colours red, green and dark blue are formed.

If mixing of the tertiary colours is needed, then the colours lying next to one another on the colour wheel are mixed again in a ratio of 1:1.

To achieve the full colour spectrum on the colour wheel, the primary colours can be placed on top of one another as fade-outs (optical mixing).

*The colours on the colour wheel are described as pure, bright colours. The colours that lie exactly opposite one another are complementary colours. Mixing these colours in a ratio of 1:1 should give black or neutral grey, yet the different pigment concentrations of the colours can result in changes to the mixing ratios.*

# Primary colours and colour mixing

Mixing the complementary colours in uneven proportions gives a broken colour. These are colours such as shades of grey, brown and olive. To achieve this, try out the widest range of different colour mixings. These mixed colours should, where possible, be sprayed, labelled and collected as colour fade-outs. These can be used for colour mixing tables or colour cards.

| Cyan 25% | Cyan 50% | Cyan 75% |
| Magenta 50% | Magenta 75% | Magenta 50% |
| Yellow 100% | Yellow 100% | Yellow 100% |

The colours of individual objects, people, landscapes, etc. are influenced by various factors. Apart from the colour itself, factors such as light, surroundings and surface characteristics influence the colouring of the object.

A red car on the road cannot just be painted red. The reflections of the sky and the road, as well as the relationship of light and shade must be taken into consideration. As a rule of thumb, the shade colour is a combination of the more intense actual colour of the object, the complementary colour of the actual colour, and blue.

*The actual colour of the flower is affected by light and shade in this example. The colour comes from the yellow/orange (Indian yellow) spectrum. The shadow contains a somewhat higher proportion of magenta and the complementary colour dark blue. For an exact colour match, it is useful to match parts of the picture using a photograph mount.*

With this series of colours, the following factor must be taken into consideration: one of the colours contains blue (cyan). A more intense actual colour in combination with the complementary colour is often sufficient to represent the shade colour accurately.

Shadows from multi-coloured or colourless objects can be achieved by mixing neutral grey from the primary colours. For colours such as ochre or red/brown, take the complementary colour of the predominant pigment of the actual colour.

For example:
ochre (yellow) – dark blue/violet
red/brown (red) – cyan/blue-green
grey – more intense grey + blue.

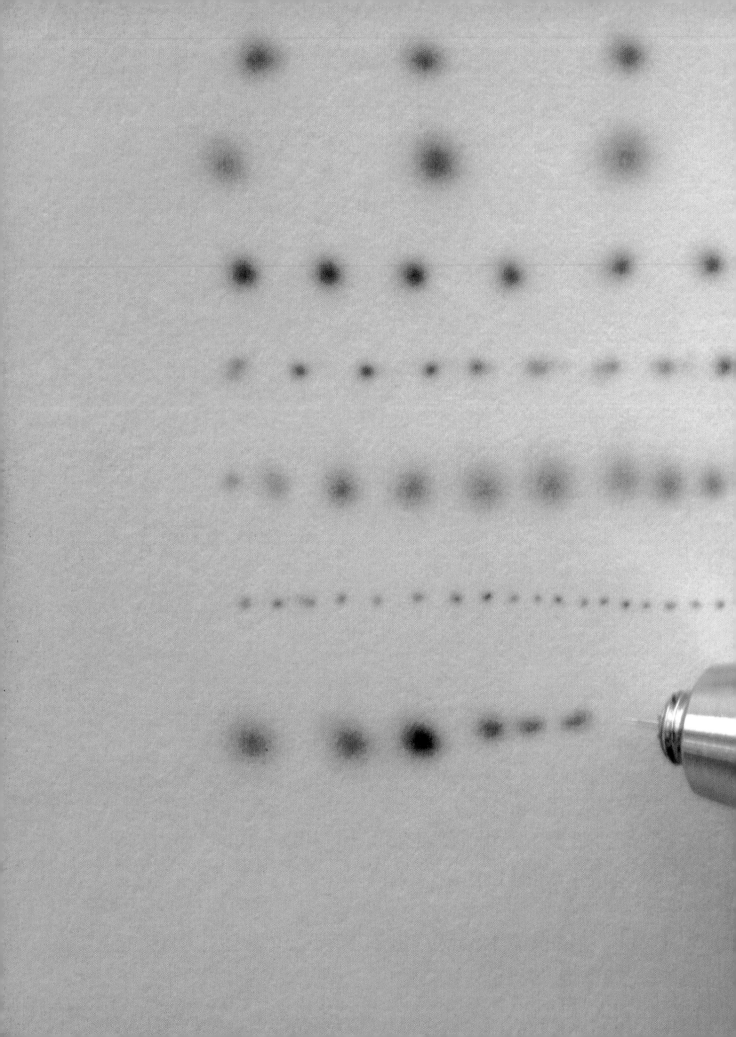

# BASIC EXERCISES

# Dots, dot-line, line

These initial exercises are essentially designed to familiarise you with using the tools. There is no universal method, given all the different airbrush guns and sprayable paints available. It is a matter of trying them out and practising. Depending on the materials used, experiment with how much the paint can be thinned or how high the air pressure should be set in the compressor (or other source of compressed air).

If the paint is too strongly pigmented or viscous, higher pressure should be used with a smaller nozzle diameter. As a rule: the thinner the paint, the lower the air pressure.
The purpose of the initial exercises is to get a feel for when and how much paint comes out on to the base.

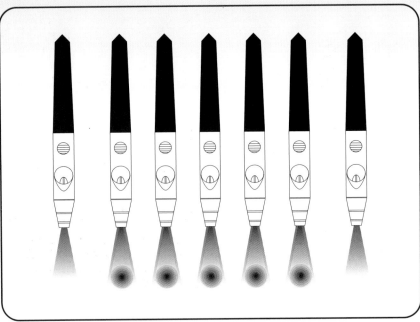

*Air on, hold air. Trigger back – dot forms – trigger forward and hold air. Repeat sequence while retaining the air.*

dot being sprayed on to the paper. The air supply should be maintained.

The dots should then be sprayed on to the base at varying distances apart. It is important to maintain an even supply of air for this, and to control the amount of paint just by forward and backward movement. Do not stop the air supply until the work is complete.

## 1. Dots
As an initial exercise, only dots are sprayed. This procedure teaches the basic use of the spray gun.

Each action with the airbrush starts with the air supply. For airbrush guns with independent double trigger action, just press down the trigger so that only air escapes. For airbrush guns with connected trigger action, move the trigger back only slightly so that only air escapes.

When the air feed is open, carefully move the trigger back and forth. This movement is usually barely perceptible, and should result in the first

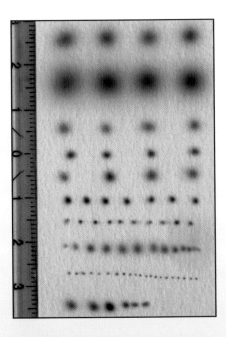

*An example of dot practice, with varying distances and intensity. In this example, the nozzle diameter used was 0.3mm.*

# Dots, dot-line, line

Even if these exercises appear to be easy and uninteresting, it is best to start with them before tackling more difficult options. Learning how to use a spray gun is comparable to learning to write at school: small a's, capital A's, small b's, capital B's, then the first word, followed by the first sentence. And, before long, the first novel!

**Important: The sequence of work**

**First the air, then the paint.
Pull back for the paint – then air off.**

**If this sequence is not followed, the gun may 'spit' or make blots. Practise as much as possible at the start.**

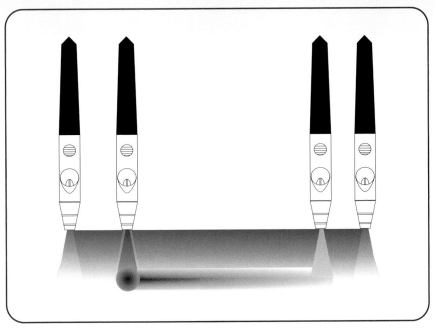

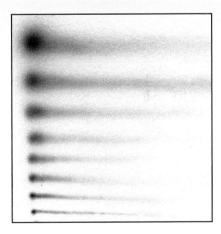

*This picture shows spraying with paint that has been barely thinned. The thin lines easily gum up the needle with pigment deposits.*

*Air on, hold air. Trigger back – dot forms. Guide gun in a line and stop paint. Hold air. Repeat sequence while retaining the air.*

*Here, highly thinned paint has been sprayed. To spray fine lines, the paint should be thinned a bit more and the air pressure reduced.*

## 2. Dot-line

This exercise touches on the previous method of working. The sequence is:

air on – trigger back – guide gun in a line, while moving the trigger forward again, stopping the paint, but holding the air.

With this exercise, too, try out different distances from the base. If the paint is held for too long or the distance to the base is too small with too much paint, blobs can form or the colour can run.

Also try guiding the airbrush gun over the paper at different speeds to get a feel for when the paint 'runs away'. This often happens when working too slowly with too much paint. Working too fast with too little paint can lead to breaks in the line.

For this exercise as well, practise until there are no splashes or blots in the sequence.

# Dots, dot-line, line

**The purpose of the following exercise is to practise an even movement of the airbrush. For good results, it is essential to guide the spray gun evenly, starting and finishing the paint smoothly within a single movement.**
**For better control, use the other hand for support. The hand can also be placed on the base.**

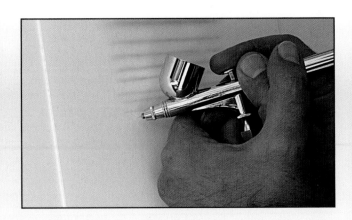

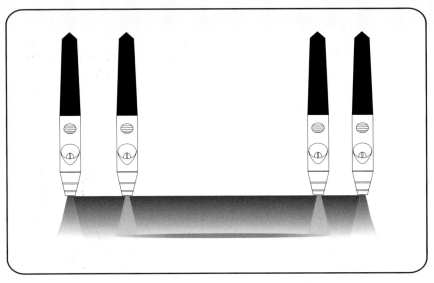

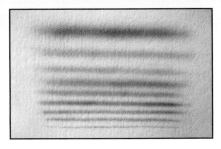

*The photograph above shows lines that have been sprayed at different distances from the base. To be able to work very finely, the paint should be thinned accordingly.*

*Air on first. Then, while moving, gently pull back the trigger so that the paint starts. Paint to the end in a line. Air off.*

### 3. Line

With this exercise, as with the dot exercise, start with the air on. With the subsequent movement of the gun, the trigger is pulled back, so that the paint is discharged. When doing this, it is important to guide the gun-hand smoothly and to keep a constant distance from the base for an even line. At the end of the line, the trigger is moved forwards again, so that the paint is stopped. When this work sequence is finished, the air supply can be stopped, too.

With this exercise as well, a large number of variations should be tried out. From right to left, from top to bottom, thick, thin, etc.

*If the initial exercises are performed without any difficulty, then the first complex figurative images can be practised.*

# Surfaces, fade-out

In this exercise, the spray gun is used more generously. The skill involved in spraying a surface should not be underestimated. An even application of paint without streaks, blots or other slips is the aim of this exercise. The material used also plays a significant role here. The paint must not be thinned too much otherwise it will form blobs; bases such as paper will become too sodden; or droplets or runs will form on non-porous bases such as plastic, lacquer, etc. Equally, it should not be too viscous, which will cause the paint to speckle when applied.

Maintaining an even distance and paint application are crucial for an even surface. There should be sufficient time between individual spray runs to allow them to dry so that the paper does not become distorted, which would lead to blobs or streaks on the surface.

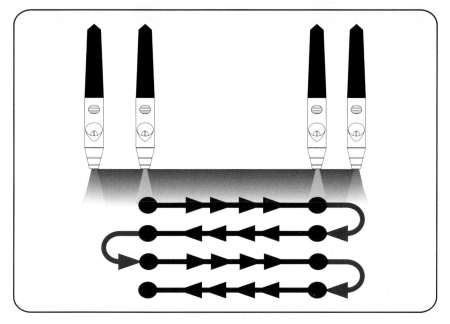

*The diagram on the left shows the sequence for covering a surface. The process always follows the same sequence, but can be repeated more often and from a greater height.*

*Masks can, of course, be used with this exercise. Above: loose shields produce a softer edge. Below: adhesive masks give sharp definition to the edges.*

## 4. Surfaces

To spray an even surface, very wide, even lines are sprayed parallel to one another. As with the previous line exercise, start with the air on, start the paint while moving the gun, and at the end of the movement switch off the paint and retain the air. The next movement should be in the opposite direction, slightly staggered, but following the same sequence. The procedure is repeated until the desired surface has an even covering.

Depending on the intensity aimed for, it might be necessary to spray several layers. The work can be performed horizontally, vertically or diagonally, but always very evenly so that there are no streaks.

# Surfaces, fade-out

This exercise is almost identical to covering a surface. For this, the distance to the base is gradually increased while moving the gun, so that the tone of the paint slowly gets lighter.
In most pictures there will be a wide variety of fade-outs. This exercise should be repeated, in different formats, until the task can be performed without any blobs or streaks.

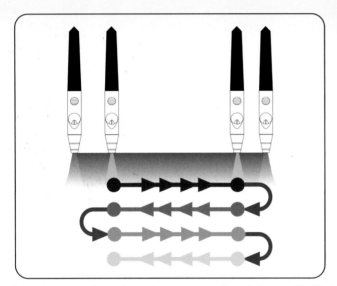

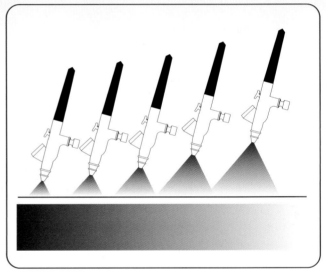

*The diagrams above show the procedure for a fade-out. The first lines are sprayed with a more intense application of paint, then the distance to the base is gradually increased, as well as the distance between the individual lines. All the while, the application of paint is gradually reduced.*

### 5. Fade-out

For a fade-out, the procedure begins, as in previous exercises, by turning on the air. While moving the gun, turn on the paint to form a somewhat wider line. When changing direction for the next, even wider, line close to it, the paint supply is continuous and the air remains constant. The distance to the base, however, is gradually increased. This sequence, with evenly escaping air, is repeated at increasing distance, line by line.

Make sure that there are no streaks here either, and that your work is not too wet. It can be useful to dry the sprayed surface from time to time with the air expelled from the spray gun.

*To achieve really even fade-outs (e.g. for a background), masks can be used. Spraying evenly without using a covering is not entirely impossible, but it does take a lot more time.*

The following basic exercises involve trying out different options for working with and using various masks, as well as options for combining airbrush technology with other painting tools.

## Self-adhesive masks

The use of masking film or adhesive tape enables very sharp, exact contours to be created, as required, for example, for script and logos.

The following steps are recommended. Pull back the backing paper on one side of the film by 2–3cm (¾–1¼in) and fold it over. This fold will stabilise the edge and the uncovered masking film can be fixed smoothly to the base.

Masking film is usually extremely soft and falls in folds or adheres to itself once the backing paper has been removed, which can often cause problems when masking large areas.

Next, the backing paper is slowly pulled away from underneath, while the masking film is smoothed down on top.

Masking film adheres to smooth bases very well. With slightly textured bases, the adhesion

is less. Some bases, such as canvas, are not suitable for using masking film on.

Different masking films have different adhesive properties. The better the adhesion of the film, the greater the danger that the paint application or the surface of the base will be damaged.

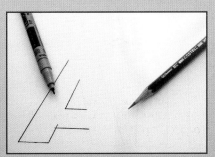

*Should the mask be drawn on with a marker pen or the paper drawn on with a pencil?*

Another aspect to consider is sketching the outline. The option of drawing contours on the film using a marker pen or pencil has the advantage that the contours are easier to see. The disadvantage of this method is that the lines are often wider and therefore less precise. If the film has to be removed, then the outline is often lost.

# Self-adhesive masks

Cutting the film is something that requires particular skill. Usually, very little pressure on the cutting tool is sufficient to cut through the masking film.

A really sharp blade is needed for this. Trying to cut a contour using a blunt scalpel will usually require too much pressure, causing damage to the surface of the base or resulting in the film not being fully cut through.

Cutting sharp corners that need to be separated from the rest of the film is another important skill. These must be cut very accurately so that the film comes away from the base without problem.

After unmasking and before spraying, carefully press down the cut edges. The subsequent spraying should also be done very carefully. The adhesive film provides some security, and it is

tempting therefore to apply too much paint too quickly, causing

droplets to form at the edge of the film. These can then get under the film and lead to an untidy edge.

To avoid this, the application of paint must be done very sparingly in several thin layers.

Additional protection can be achieved by pre-treatment of the cut edges with airbrush thinner. The thinner is sprayed wetly over the edges of the unmasked surface before applying the paint, so that the thinner can get under the cut edges of the film. After a short drying time, the edges are sealed and then the application of paint can begin.

The possibility of the paint running under the film also depends on the surface texture of the base. With rougher textures, the risk is higher than with very smooth surfaces.

The use of adhesive tape is comparable with that of masking film, although the different levels of adhesion of the various types of adhesive tape should be borne in mind. Crêpe tape varies in its adhesive qualities, and film that adheres too strongly can quickly destroy the surface of a base.

*The picture shows the damage that masking film can cause. The small, dark speckles are the result of film that adhered too strongly and removed some of the paper fibres when it was pulled away, and on which the paint spray has collected when over-spraying. The torn places were caused by pulling away the crêpe tape around the edge. Another factor for this loss is the poor quality of the surface of the drawing board.*

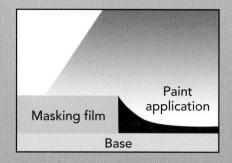

When using adhesive masks, note that if large amounts of paint are applied to the edges of the mask, crusts will form that could be problematic, especially for objects needing to be lacquered.

# Self-adhesive masks

Pieces removed from a mask that has to be reused should be saved on flat backing paper. These individual pieces can then be stabilised later with a piece of smooth paper (see right), and fitted exactly back into the space.

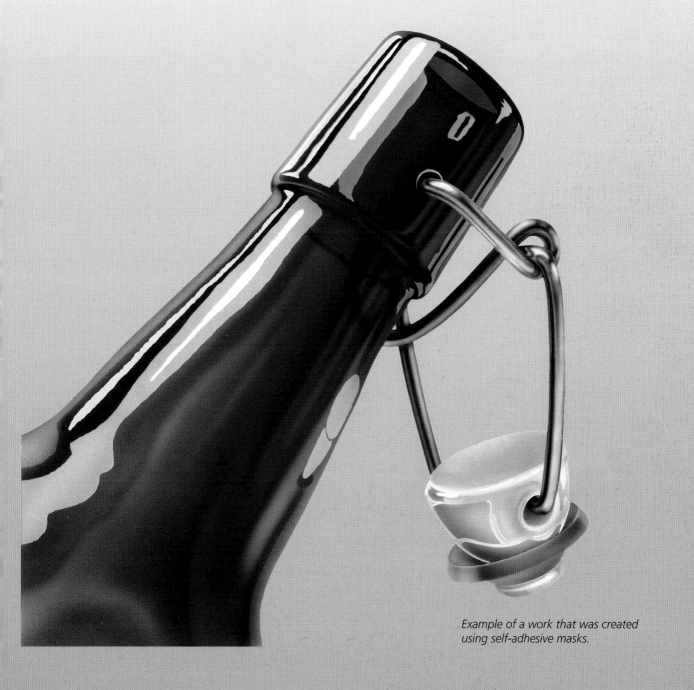

*Example of a work that was created using self-adhesive masks.*

# Self-adhesive masks

Loose shields offer many possibilities for protecting picture surfaces from the spray mist. The paper or card stencils that are generally used are easy to create and can usually be re-used several times.

Paper stencils can be cut from sketching or copier paper and fixed using spray adhesive, spray mount, adhesive tape or with the help of a metal sheet and little magnets.

The option of fixing loose shields with magnets reduces the danger of damaging the base or areas of the painting that have already been painted, which is something that can happen when using self-adhesive masks.

When using spray adhesive, bear in mind that it is available in various strengths. Adhesive for loose shields should be removable. After the reverse of the loose shield has been sprayed with adhesive, the adhesive should be allowed to dry for a few minutes. If any adhesive deposits remain stuck to the base, they can be carefully removed with a soft cloth and benzine.

Working with loose shields enables the creation of hard and soft edges, depending on the distance of the shield from the base.

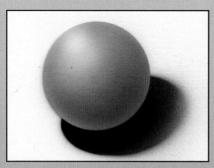

*In this example, the mask, made of sketching paper, was loosely placed, giving a sharp contour when a light spray mist was applied. When the mask is lifted, a smooth transition from the hard to soft form is created.*

The spray results also largely depend upon the way the spray gun is held.

To avoid too much spray mist getting under the loose shield, the airbrush gun should be held vertical to the base when working.

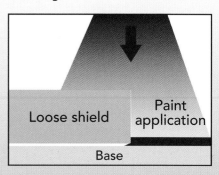

By holding the gun vertically, the loose shield will also be pressed on to the base by the airflow.

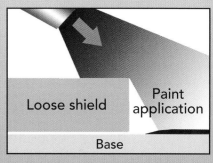

Holding the airbrush gun at an angle will cause light edges or swirling paint that will lead to uneven paint application around the contour.

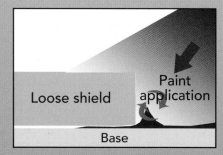

Another factor is the airflow, which will lift the loose shield if the airbrush gun is held at an angle, causing more spray mist to get under the mask. Masks from thin paper soon become distorted, which causes similar problems.

# Self-adhesive masks

Loose shields make it very easy to create soft overlaps, such as are necessary for the demarcation of the texture of fur, for example. To make this type of mask, the outer edge is perforated using cuts made close together and then torn out.

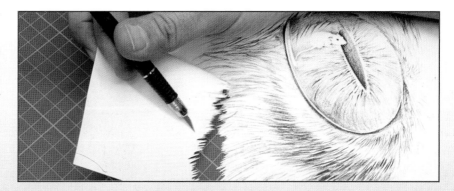

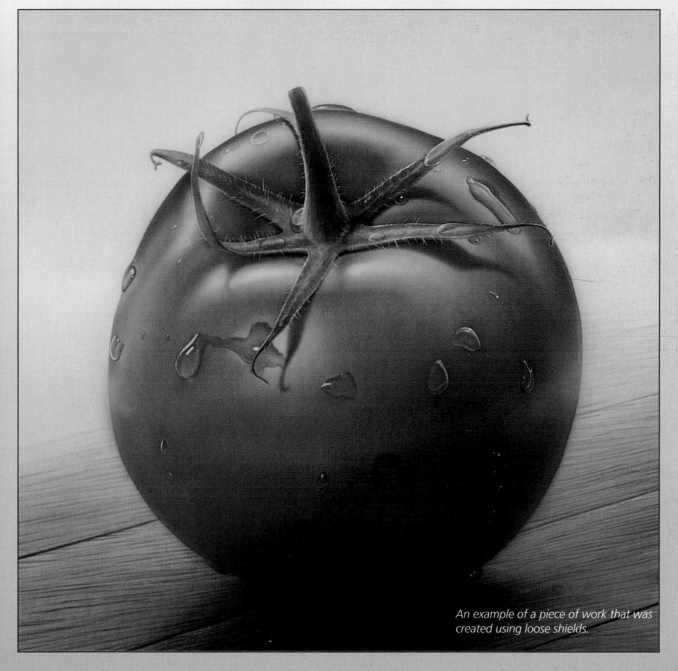

*An example of a piece of work that was created using loose shields.*

# Other aids

For some pieces, it is necessary to use brushes in combination with the airbrush gun. Brushes can be used to retouch small errors, paint points of light or contour edges and depict hair, grass or cracks. Textures can quickly and easily be created with the help of various brushes, sponges or films.

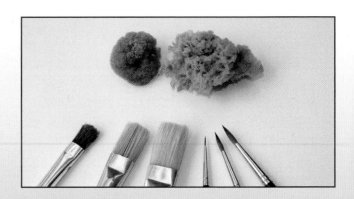

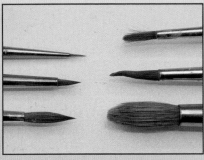

*Examples of some fine brushes made out of red marten hair. Top left brush: size 000 for tiny, detailed work; middle left brush: a retouching brush in size 4; bottom left brush: a universal-use red marten hair brush in size 5. On the right are models that can only be used for cleaning the airbrush gun or for mixing paint.*

The paints to be used should be mixed according to the instructions. In most cases, thinning with water is sufficient for water-based paints. For acrylic and airbrush paints, some medium and/or drying retardant should be added.

With a little practice, even the finest of lines can be drawn with the brush. For longer, thin lines, a consistent distance is required, which can be achieved by supporting your hand on the base.

Working with an animal-hair brush does not usually require a great deal of practice. When choosing the brush, attention should be paid to the quality and the size. Very cheap brushes or synthetic bristle brushes do not usually form a fine enough tip for most work, or they wear out very quickly. Extremely fine brushes in size 0, or smaller, hold very little paint and are therefore suitable only for small, detailed work.

Once the paint has been taken up, the brush should be drawn quickly over a piece of paper or cloth, while being slightly twisted at the same time to reduce any excess of paint and to form a pointed tip.

To protect the base, e.g. when retouching, a piece of paper should be inserted or a thin cotton glove should be worn.

Brushes and bristle brushes, in combination with the spray gun, are good for creating the texture of wood.

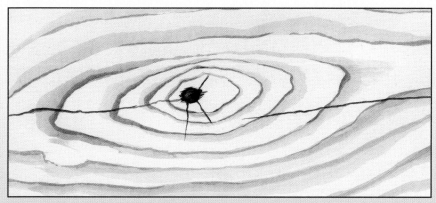

*The initial lines are drawn in advance using an animal-hair brush.*

In the same way, a bristle brush can be used to create the texture of fur or grass, which can then be worked on with the airbrush gun.

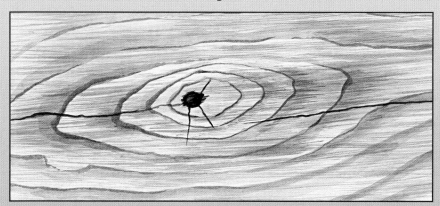

*Using the same colour, the texture is embellished with a bristle brush and very little paint.*

Dotting with the bristle brush gives irregular speckled effects, e.g. for marble and the textures of stone or rock.

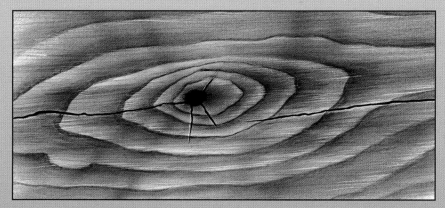

*Finally, the colour is worked on using the spray gun, so that the lines painted with the brush fade into the background. Some light is scratched in using the scalpel.*

For this exercise, the quality of the paper is important. On simple paper, such as that for sketching or drawing, the thinned paint has a tendency to run and softens the surface of the paper. For this type of exercise, airbrush paper or airbrush card should be used.

Similar textures can also be achieved by dotting with a natural sponge. Here, too, ensure that the work does not get too wet, and keep turning the piece of sponge so that the texture has more of an uneven look.

# Other aids

The texture of rust is good for practising dotting.

*The first rough sketch is painted using an animal-hair brush and thinned paint.*

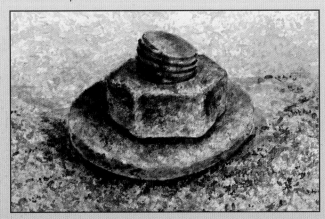

*Next, the rust texture is dotted using a small natural sponge and a bristle brush, and then the background is covered using a rougher sponge and a different thinned paint. If the outline is accidentally exceeded, it will barely be noticed with this type of texturing.*

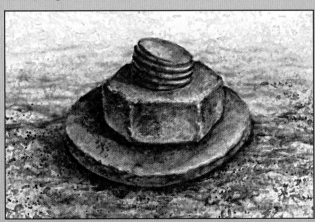

*Finally, the colour is worked on further using the spray gun, some mossy patches are dotted on using the bristle brush, and light is added using the eraser and the scalpel.*

Among the tools that are virtually indispensable are erasers and scalpels. These tools have several different uses, and many factors need to be taken into consideration.

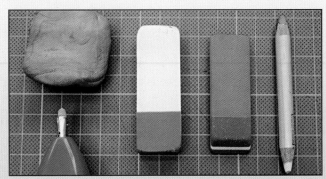

First, the degree of hardness of the eraser and the quality of the base are important. Erasers ranging from very soft (a modelling eraser) to very hard (watercolour or fibreglass erasers) are available. Paper or card can have a very rough and often soft surface, or a smooth and firm or even-coated surface.

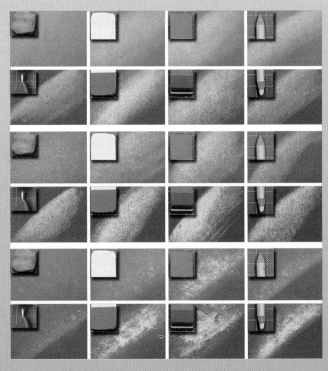

*Examples of different bases and erasers. First and second rows: drawing board. Third and fourth rows: primed drawing board. Fifth and sixth rows: a soft base. By means of the various erasers and the varying surface characteristics of the bases, different results can be achieved. The pressure exerted when erasing is another factor to be taken into consideration.*

Because of the many different materials used, the erasers selected should be tested on different bases. The desired results also depend upon how the eraser or blade is used, as well as on the paint used for spraying. In some cases, an excessively weakened surface cannot be avoided. Places where the paper fibres have been 'roughed up' can often be smoothed down somewhat by spraying airbrush primer over them several times.

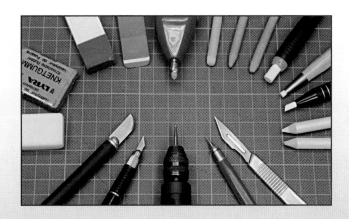

Very smooth bases with a firm surface enable the spray paint to be removed virtually without trace.

Bases with a rough, textured surface are often quite difficult to remove paint from. Intense paint application that penetrates the texture of the paper can often be removed only by damaging the surface. These paint deposits (e.g. in a rough canvas texture) can often be completely removed only with the help of an air-eraser.

The eraser should be smoothly and evenly applied to the base to avoid creating a dirty, irregular surface. It is best to start with a soft eraser and change to a harder one only if this proves to be inadequate.

Some paints have a tendency to adhere to the eraser. Any such deposits should be removed using rough abrasive paper or a knife.

*Soft eraser pencils often need to be sharpened after erasing thin lines.*

*A good alternative for erasing thin lines is the electro-eraser.*

*For really fine, light lines, scraping with a scalpel is an option.*

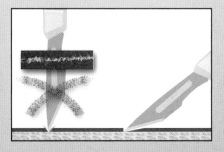

When scraping or scratching with a scalpel, the blade should not be held too stiffly, as this often leads to tearing of the paper fibres.

The texture of fur or grass can be achieved with the scalpel (example above right) or with rough abrasive paper.

A rough paper texture can be scraped flat with a razor blade, e.g. for depicting stone or rock.

# STEP-BY-STEP
## Basic geometric shapes

All of the materials listed at the start of each project are those used by the artist himself. If you do not have the specific items listed, equally good results can be achieved with suitable alternatives.

# Basic geometric shapes

## The materials used in this project

**Airbrush paints:** Schminke Aero Color Professional primary colours in yellow, magenta and cyan blue.

**Airbrush:** spray guns, AMI 200, AMI 300.

**Base:** illustration board, Schoellershammer 4G, 35 × 50cm (13¾ × 19¾in).

**Masking film:** Frisket film, matt.

**Scalpel with straight blade.**

**Cutting ruler or set square.**

**Basic geometric shapes**

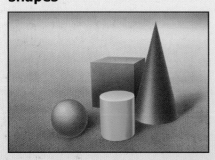

This project is essentially intended to help you spray even fade-outs. These fade-outs give the individual objects their vividness. The picture uses only the primary colours yellow, cyan and magenta. By using primary colours, beginners can start to learn how to mix colours. The materials specified are not absolutely necessary for this project. The work can also be done on any airbrush paper, with another type of gun and other paints or colours.

When using paints from other manufacturers, the mixing ratio can vary considerably from that shown in the examples here. Also, when a manufacturer revises its colour palette, this can lead to differing paint mixes.

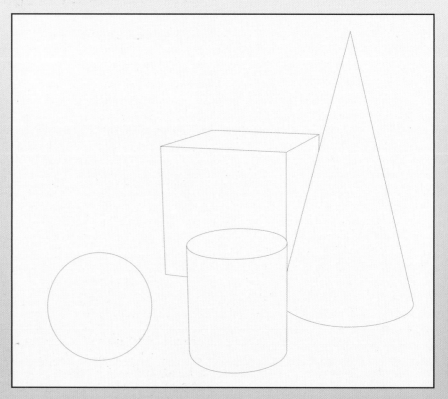

Begin by drawing on the base and cutting out the masking film. The film is cut a little bigger than the base, so that the whole base is covered.

To pull the masking film and backing paper apart, pull a strip of backing paper approximately 3cm (1¼in) wide away from the film, and then fold the backing paper over along this line. This provides a stable adhesive edge

to hold the masking film, which can then be placed on the base easily and fixed in position.

Press down firmly with the ruler on top of the film, and pull the backing paper away from underneath.

After the backing paper has been pulled away and the film smoothed flat, carefully cut out all the lines of the drawing, cutting just the film and not the card.

For the straight edges, use a ruler to help you.

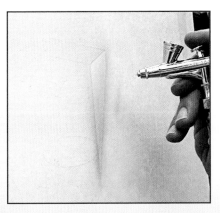

To create the colour for the cube, mix a dark blue from two parts magenta and one part cyan blue. Thin this mixture with water until a clean spray pattern is achieved. Most dark shades are very strongly pigmented, and therefore need more water or medium.

Remove the film from the side surface of the cube and press the edge of the film down firmly, so that no paint runs under the film when spraying.

Next, spray the surface in several thin layers at some distance from the base, moving from bottom (dark) to top (light).

With this exercise, it is essential to work evenly. The paint flow should be such that the paint is not too wet when it touches the base. The base absorbs some of the moisture, but droplets of

paint will form really quickly at the edge of the film, and can then run under the mask.

Paint running underneath can be avoided (or reduced) by applying airbrush primer after unmasking and pressing down the edges. This is transparent and seals the edges immediately.

After removing the mask from the front surface, spray the fade-out again from bottom (dark) to top (light). The previously sprayed surfaces remain unmasked and therefore become more intensely coloured.

The front surface should remain somewhat lighter than the side surface and also show an even fade-out.

# Basic geometric shapes

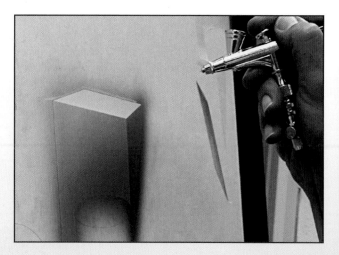

In the same way, cover the top surface of the cube. First unmask, press down the edges of the film and, if necessary, seal. Then spray the fade-out from the top (darker) to the bottom (lighter). Make sure that the top surface remains a little lighter than the front and side.

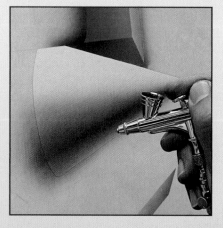

To cover the blue surfaces of the cube, prepare a piece of copier paper with low tack, fine line masking tape. The fine line tape is stuck to the paper with the adhesive surface overlapping the edge by 1–2mm. The areas of the picture that have already been sprayed should have as little contact as possible with the adhesive film, so that it does not pick up any paint from the base.

Next, unmask the cone and press the edges down firmly. To paint the cone, mix one part yellow with three parts magenta. The paint mix can be further thinned with some water.

This paint mix is first used to cover the shaded side of the cone. Lay the painting on its side for this, as a horizontal movement when spraying is usually easier than a vertical one. A feature of this shape is the cone-shaped fade-out of the area of shadow. To create this, the gap between the airbrush gun and the tip of the cone is kept very small, and is then slowly increased while spraying from right to left.

During this work, the surface of the cube will have had some time to dry before the blue surfaces need to be covered to protect them from the red spray mist.

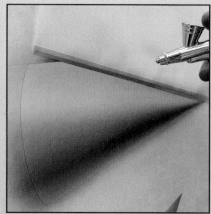

Once the blue surfaces are protected, the rest of the cone can be painted. Spray the left side of the cone, as shown here (above), taking care to ensure that the light area of the cone follows the shape.

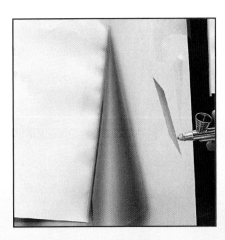

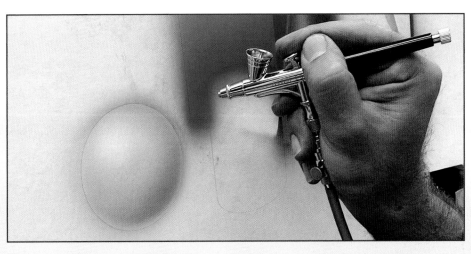

Once the cone shape has been sprayed with red paint, the colour work can continue with thinned yellow paint. This is done by spraying the transparent yellow on to the overlapping areas from the light to red fade-out.

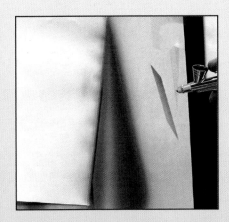

To give more volume to the shape, the area of shadow is made a little darker with thinned magenta.

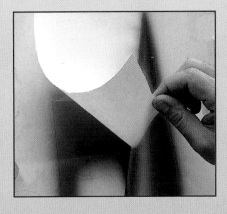

For the ball, mix a colour from three parts yellow and one part magenta, and thin with a little water. Unmask the ball and press down the edge of the adhesive film. To give the ball its shape, spray the shadow underneath and to the right intensely with several overlapping layers of paint from a reasonable distance. Work on the fade-out up to the light on the ball by gradually increasing the distance from the base. When spraying the ball, use circular motions following the outer edge.

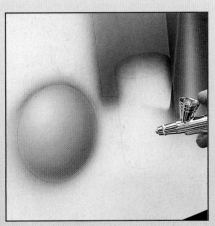

By overlapping many layers of paint in this mix of yellow and magenta, the dark magenta pigment will significantly dominate. This colour mix results

in a range of colours from yellow/orange to an intense red.

Colours such as Indian yellow or orange often consist of a narrow range of pigments, which is why shading from light to intense is all that is possible with one of these colours.

The green for the cylinder is mixed from three parts yellow and one part cyan, and thinned with water. Once the film has been removed from the cylinder, the neighbouring areas can be covered using copier paper and fine line tape.

To ensure that as little adhesive tape as possible adheres to the areas of the picture already painted, additional pieces of

# Basic geometric shapes

paper can be fixed under the adhesive tape.

Even if the dried paint seems to be well adhered to the base, always remember that adhesive tape can pull away the paint when it is torn off. Once the cylinder shape has been covered, the film can be removed from the surface areas.

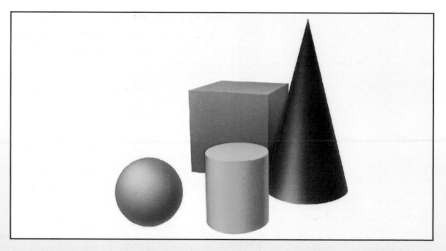

Now, to protect the blue area of the cube from the spray mist, the previously removed mask from the front surface of the cube is re-used. A piece of copier paper is attached to this mask so that just a few millimetres of adhesive surface remain free for fixing the mask to.

One of the advantages of this method of working is that the mask is made more stable by attaching the paper, and is therefore easier to place.

Finally, spray the fade-out for the top surface, more intensely at the top to lighter below.

Next, all the masking is removed from the base and the sprayed surfaces are sealed with a medium. The protected areas of paint are re-masked after drying.

In the next part of the process, crêpe tape is stuck around the edge, before the top part of the background is covered with a colour mix of one part cyan and one part magenta, thinned with a little water.

So far, the AMI 200 airbrush gun has been used. For small areas and fade-outs, it is best to use a gun with a small paint reservoir and a nozzle diameter of 0.2mm.

For the large areas of background, an AMI 300 gun is used. It has a larger paint reservoir and a nozzle diameter of 0.3mm, enabling quicker working. However, the somewhat smaller AMI 200 can be used just as easily for this task; it simply needs to be refilled more often.

Painting the fade-out in the background is done in exactly the same way as for the geometric shapes, at a reasonable distance from the base and with a very even movement of the spray gun. After the first fade-out in blue, dark above to light below, comes the second fade-out, which is intense below, getting lighter above, in a mix of eight parts yellow, six parts magenta and one part cyan.

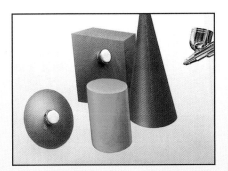

This colour mix is then thinned with some water and applied in several thin layers.

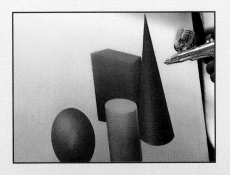

When covering the ground area, work at some distance from the base to avoid the appearance of streaks.

Next, the nozzle cap of the airbrush gun is unscrewed. With most screw-in nozzle guns, it is possible to achieve a speckled effect. When a spray gun has a socket nozzle, a special speckle cap needs to be used to achieve

this effect. This technique is used to apply larger speckles at the bottom of the picture and finer ones towards the top.

Using the same paint, and having screwed the nozzle cap back on, lightly indicate the shadows cast by the shapes and, finally, unmask the whole work.

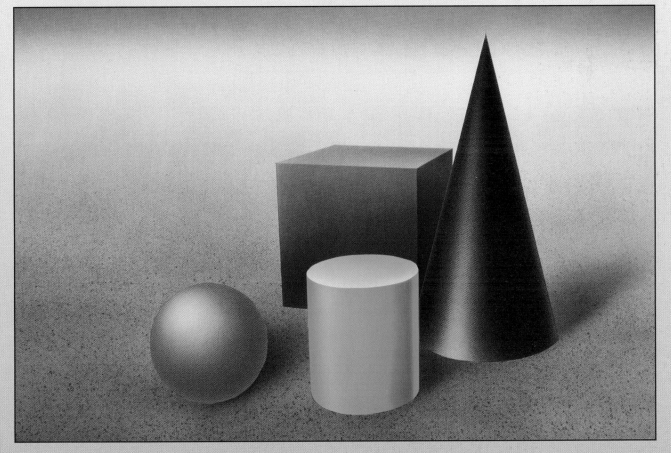

# STEP-BY-STEP
# Lily

# Lily project

## The materials used in this project

**Airbrush paints: Vallejo.**

**Airbrush: Harder & Steenbeck Infinity.**

**Base: illustration board, Schoellershammer 4G, 35 × 50cm (13¾ × 19¾in).**

**Masking film: Frisket film, matt.**

**Scalpel with straight blade.**

Begin by sketching the initial design on sketching paper. This design has subsequently been digitised and a line drawing produced on the computer.

Take care not to press too firmly, in order to avoid indentations in the base.

Check at the outset that the traced lines are dark enough to be seen.

Cover the whole design with Frisket film, and cut all the lines of the initial drawing.

Wearing a cotton glove enables the hand to glide more easily over the base when cutting the film.

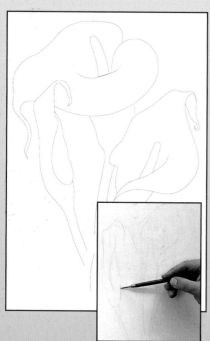

The design is transferred on to the base with the help of a print-out of the outline drawing.

This print-out is shaded in pencil on the reverse, then fixed to the base and, finally, all the lines are traced through with a hard pencil.

# Lily project

A mix of two parts olive green, three parts yellow and some water is used with Infinity by Harder & Steenbeck with a 0.4mm nozzle.

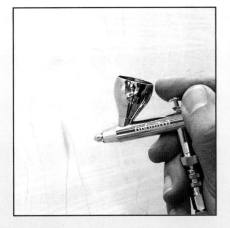

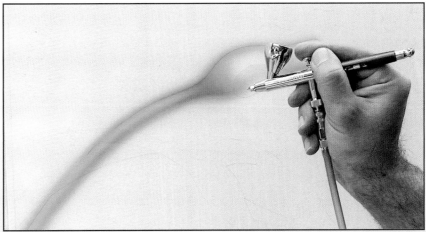

Unmask the first part of the picture and press down the edge of the masking film before spraying the surface. It is important that the paint is not applied too wet. The somewhat larger nozzle diameter enables faster working, but with the danger that too much paint will be applied too quickly.

Using the same colour mix, spray the first flower stem with a bud. To do this, the painting should be laid on its side, as it is easier to move the airbrush gun horizontally.

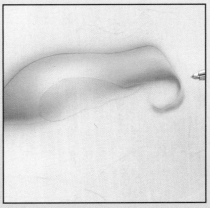

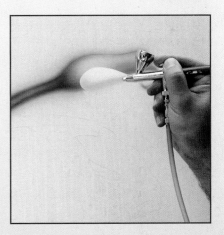

Once the shape has been covered, the remaining mask on the bud is removed, the edge of the film pressed down again and then the shape is painted in the same way.

In this step, the shape is given volume. Cover the outside edges of the shape with more intense colour, and colour the light area only lightly.

The shadows on the right and underneath are made a little darker by making the colour more intense. This is achieved by overlapping the individual layers of paint several times.

After removing the cut-out film, the edges of the film should be carefully pressed down once more.

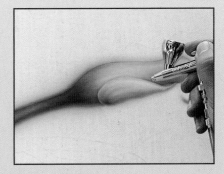

Finally, the stripy texture of the bud is indicated with some thin lines.

# Lily project

In the same way and with the same paint mix, spray the other flower stems. As before, the body of the stem is sprayed first, and then the lines that represent the texture.

The level of shading of the stems can be checked easily, as with this work the previously sprayed stems do not need to be covered again. Once the stems have been sprayed, extra details are added here and there, making some bits darker and thickening the texture lines.

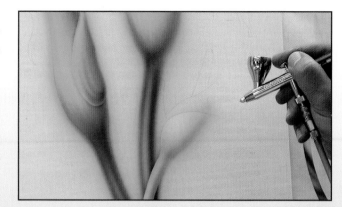

The shadow beneath the flowers must also be sprayed more intensely. Completely finish spraying the stems and the bud.

The stamens are then sprayed with orange paint. The parts of the mask that have been removed will be used again later and should therefore be carefully retained.

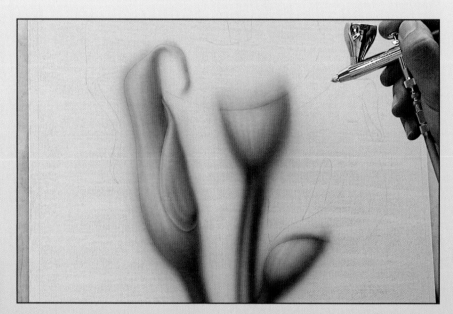

Here, the first stamen is lightly misted, and then the second stamen is sprayed. Afterwards, the first one is sprayed more intensely and then the second, always leaving some time for the paint to dry.

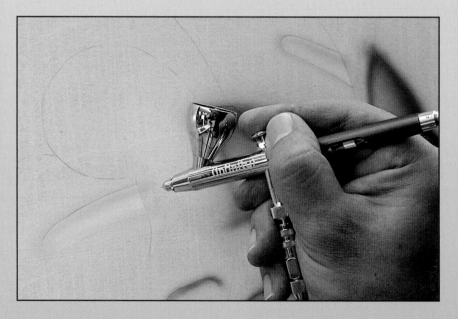

The next colour mix consists of four parts grey, one part olive green and one part orange and some water. First, spray the overlapping parts of the flower in this colour.

As before, once the surfaces have been unmasked, the edges should be pressed down very carefully, so that the small adhesive surfaces do not come away from the base. When spraying the tips of the flowers, pay particular attention to the different shades, so that the curved shape of the tip is given volume.

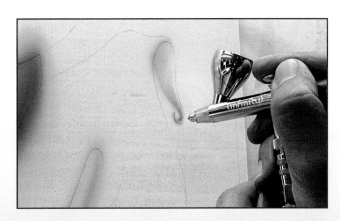

base. Afterwards, the lower area is made darker around the stamen, taking care not to allow a build-up of spray mist at the edge of the overlapping film.

on a little more with the same paint mix.

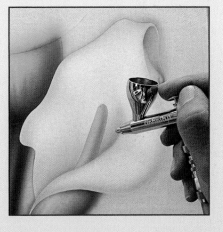

The next step involves spraying the stamens again. This is done by folding the previously removed pieces of film in half and sticking them to a flat surface, such as a business card, and then replacing them accurately. This helps to give the mask a little more stability and makes it easier to position.

Then, to unmask the upper part of the flower, the adhesive film is rolled up and fixed to the

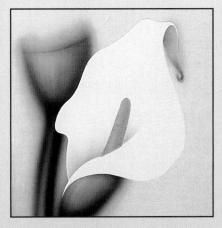

The remaining masks on the flower can then be removed, the edges pressed down and the shape of the flower worked

Work very carefully, so as not to make the colour of the flower too strong.

Work a little more on the shape of the flower, adding several thin layers of paint, and then rework the orange stamen with the same paint mix to emphasise the volume of the shape and to give depth to the calyx.

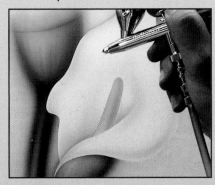

# Lily project

The second flower is worked on in the same way, without covering the previously sprayed flower again. This allows you to match up the shades well and, where necessary, make them alike. To emphasise the shapes of the flowers, some very soft lines can be added from quite a distance. Then unmask the whole work.

Before the next step, seal the whole picture area with airbrush primer. This seal protects the finished surfaces before they are masked again.

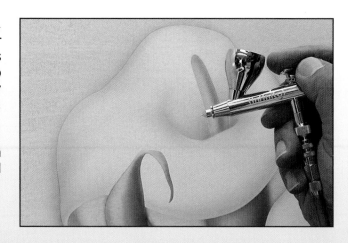

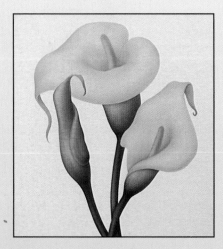

Once the base and the paint used for the flowers or the seal (if applied) are dry, cover the whole work again with Frisket film, and then cut around the outside edges very precisely. Finally, uncover the background.

Using this mix, the lower part of the background is sprayed first, gradually spraying more intensely as you move up the picture.

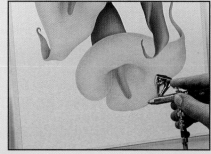

Then the piece is turned, and the top half of the picture is given a fade-out. The picture needs to be turned, as the spray mist always

sinks to the bottom, which in this instance is the darker area.

The colour of the background is thus built up layer by layer, at some distance from the base. Continue to ensure that the paint is applied evenly to prevent the appearance of streaks.

When spraying the large background areas, do not forget to allow sufficient time for the paint to dry.

Once the desired level of colour has been achieved and the paint is dry enough, the work can be unmasked.

A mix of five parts olive green and ten parts yellow, thinned with a little water, serves as the background colour.

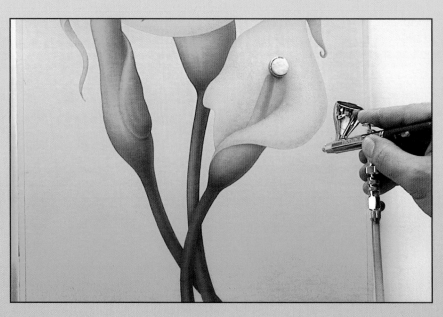

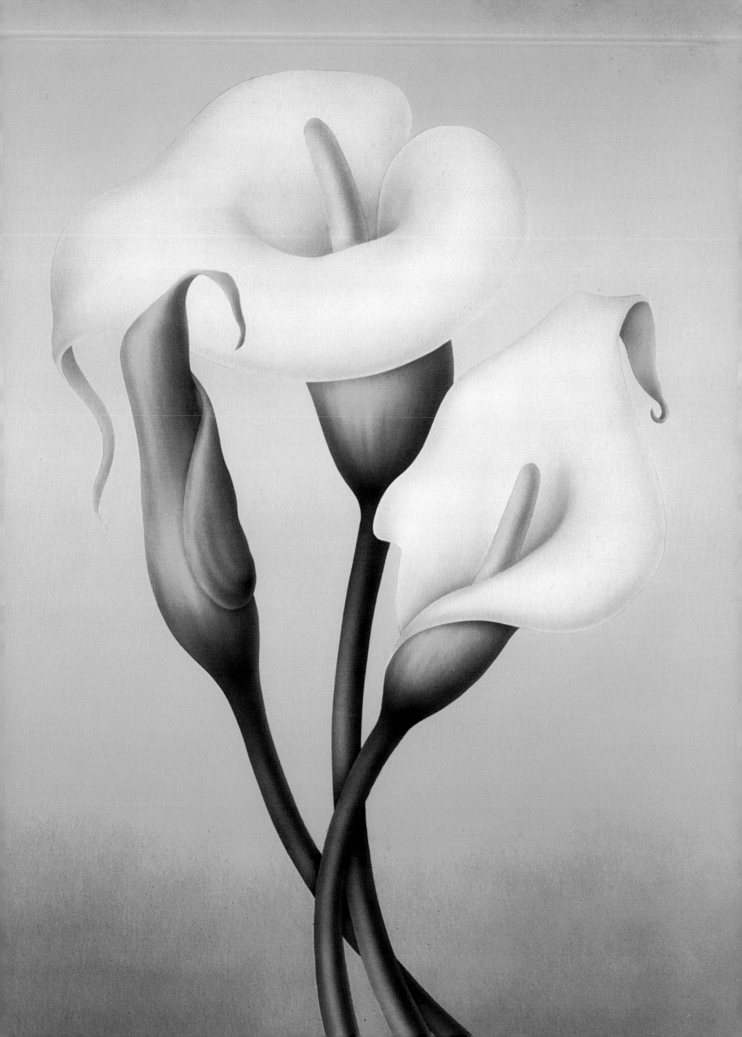

# STEP-BY-STEP
## Wave

# Wave project

## The materials used in this project

**Airbrush paints: Schmincke Aero Color Professional in ultramarine, Prussian blue, turquoise blue.**

**Airbrush: Evolution Silverline spray gun.**

**Base: Airbrush paper, Hahnemühle Fine Art, 30.4 × 43cm (12 × 17in).**

**A3 copier or sketching paper.**

**Scalpel, pencil and various erasers.**

**Metal board and magnets or adhesive tape.**

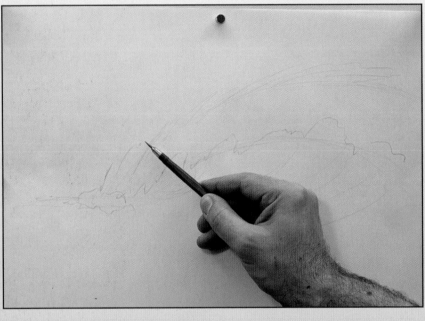

mask and crêpe tape or masking film stuck over them.

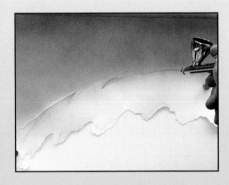

The piece is sprayed with a colour mix of ultramarine, thinned with some water. Spray the sky with this at some distance from the base.

This project provides practice in how to spray lines. For this work, a loose stencil can be used. This gives beginners a little more security when making the first individual lines.

The work begins with a rough sketch of the wave on copier or sketching paper.

The thin stencils are then cut from this paper, as a mask of self-adhesive film would make the edges too hard. The sketch serves to establish the rough shape and size of the image.

There is absolutely no need to keep exactly to this.

The first shape is then cut out and fixed to the base. Little magnets can be used to hold the pieces in places. Alternatively, little holes can be cut in the

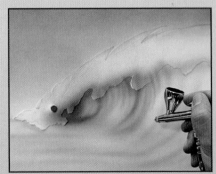

The contours of the wave and the horizontal water surface are indicated using the same colour and sprayed at some distance from the base.

# Wave project

This procedure is repeated closer to the base, slowly building up the surface texture of the wave.

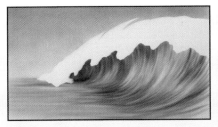

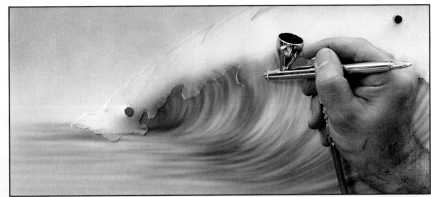

The loose shield can then be removed.

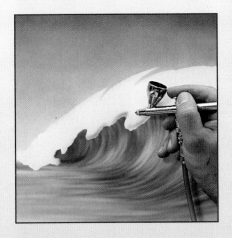

Using the same colour, work on the top of the wave some more. First, roughly spray the shadow areas. It does not matter if some spray mist goes over the edges.

The next step involves indicating the cloud-like texture of the foam. For this, the spray gun is moved at varying distances and speeds very close to the base.

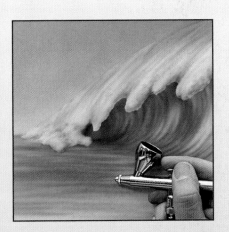

The water surface is then worked on again in more detail.

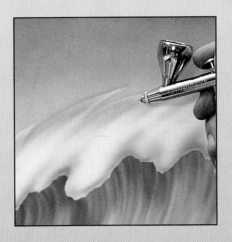

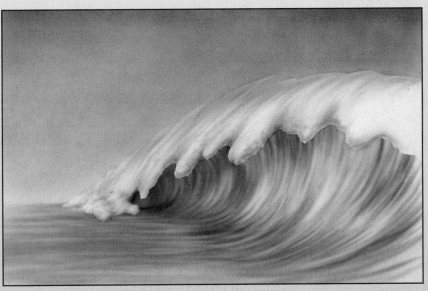

# Wave project

Make the shadow areas darker with some thinned Prussian blue. In this step, the tunnel effect at the far end of the breaking wave is emphasised as the focal point.

Work on the shadow areas in the top part of the wave with the same colour, making the cloud-like texture even stronger. As before, continue working at various speeds and distances from the base.

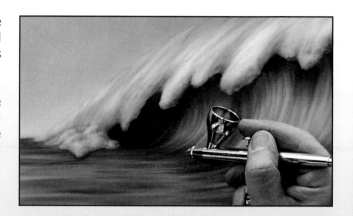

In the next step, the colour of the surface of the water is built up in turquoise blue. Work intensely and very close to the base to add details to the texture of the water surface. The foreground of the piece should have the most texture and the most intense colour. Work close to the base and move the spray gun slowly to create thin, colour-intensive lines. Finally, add detail to the texture of the wave using an eraser.

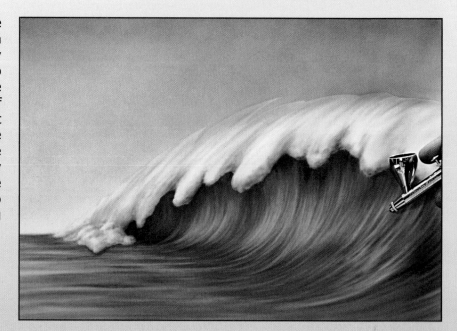

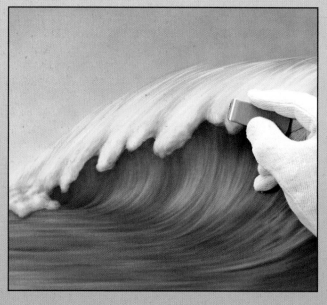

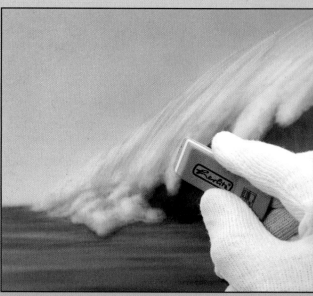

**Note about materials**
The erasers used for this exercise can, of course, be replaced by other tools. It is important that the eraser does not smear or affect the surface of the base too much. Instead of an electric eraser, a scalpel with a round blade can be used. A piece of abrasive paper is also useful for shaping the edges or points of different erasers.

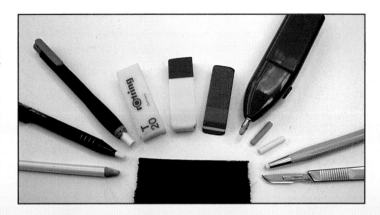

Using the electric eraser, make the first hard areas of light. Use a hard eraser lead, sharpened using abrasive paper. The surface of the picture needs to be only lightly touched to remove the paint.

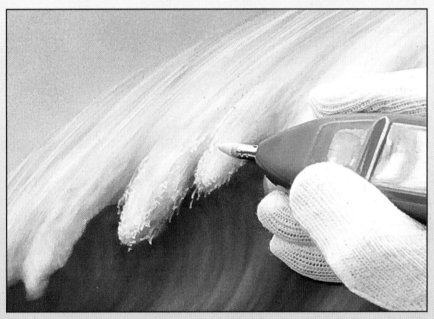

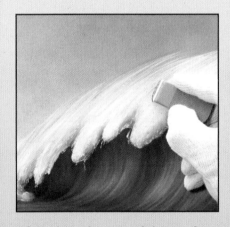

After this, the top of the surface is brightened again with the electric eraser, using a slightly softer lead. Use the eraser both across the whole width and at the corner.

For the cloud-like texture, the eraser is guided in circular motions using the corner; for the movement lines at the back of the wave, the edge of the eraser is used.

Depending on the pressure and how the eraser is held, very different stroke widths can be achieved.

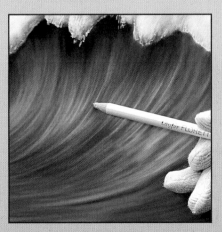

Finally, the areas of light on the surface of the water are indicated with an eraser pencil. In comparison with a simple eraser, an eraser pencil facilitates more targeted work.

Care should be taken to ensure that the erased lines follow the previously sprayed lines.

These first lines are made with the soft side of the eraser pencil (pink). Stopping and starting, as well as the pressure used, are important here.

# Wave project

The direction of movement when erasing should be in a slight curve relative to the base. This will make the erased lines tail off softly at the beginning and end.

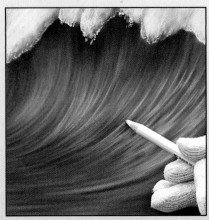

Strengthen the edges of the areas of light using the white, harder side of the eraser pencil. In so doing, the lines previously made with the soft eraser are increased in places and complemented with further lines.

Also use the eraser to create some lines on the horizontal surface of the water. To increase the contrast in the foreground, place lighter lines in the front of the picture.

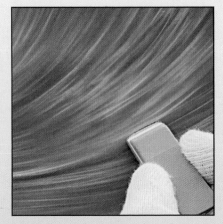

Next, emphasise some of the lines in the water surface using the hard eraser. The whole edge of the eraser is used here to create really light, smooth edges.

The edge of the eraser should be sharpened with some rough abrasive paper if necessary.

Alternatively, a scalpel with a rounded blade can also be used for this work.

Then, using the electric eraser, complete the work on the light edges using thin lines, and create some light points on the surface of the water.

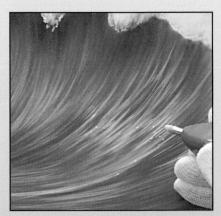

For the finishing touch, add some drops of spray to the surface of the wave using the electric eraser, or alternatively a scalpel with a round blade.

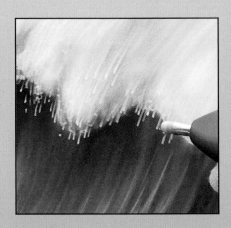

These are indicated by a small point, which changes into a fine line.

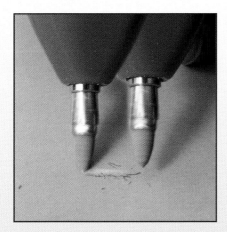

To do this, the eraser is set down briefly and then lifted away from the base in a line movement.

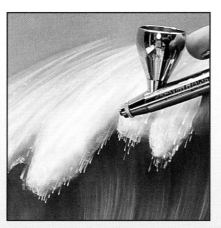

Afterwards, the top of the wave is speckled with some unthinned white paint. This is done by moving the trigger back and forth a few times without air and then briefly depressing once.

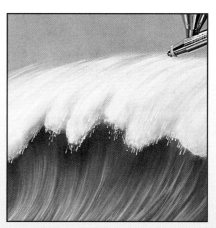

Finally, the surface is completely lightened by softening the texture of the eraser.

To do this, use the gun to follow the path of the previously erased lines.

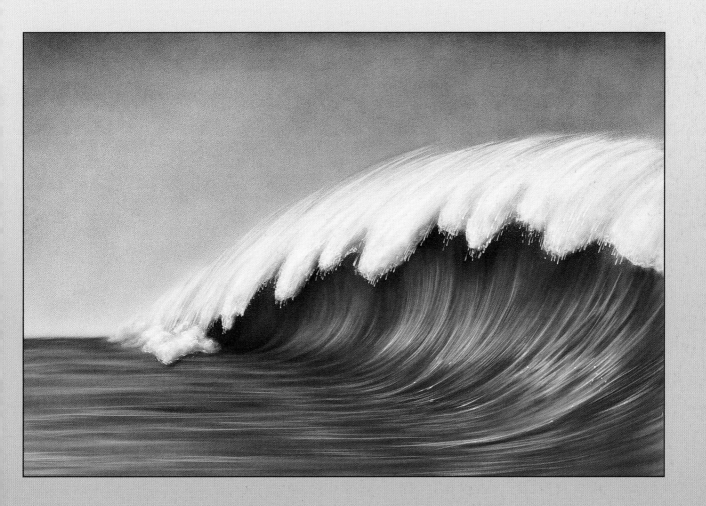

# STEP-BY-STEP
## Rose

# Rose freehand project

## The materials used in this project
**Airbrush paints: Pro-Color by Hansa.**
**Airbrush: Rich AB 300.**
**Base: airbrush paper, Schoellershammer, 35 × 50cm (13¾ × 19¾in).**
**Eraser: Herlitz.**
**Eraser pencil: Läufer Florett.**
**Coloured pencils: Polychromos by Faber-Castell.**

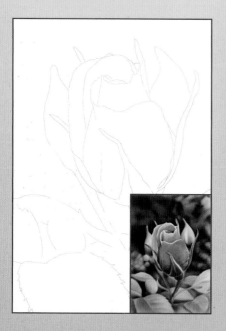

The first step involves drawing the outline on to the base. For this picture, the base has not been pre-treated.

The drawing can be done using a projector, grid, by tracing or freehand. The outlines should not be drawn with too much pressure, otherwise they will be hard to cover or erase.

The work begins by spraying the background. A mix of olive and black in a ratio of 1:1 is thinned with some water, and then the dark areas of the background are misted at some distance from the base.

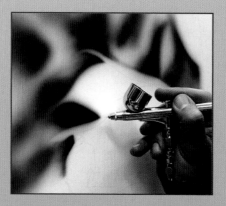

When doing this, make sure that as little spray mist as possible reaches the area of the flower.

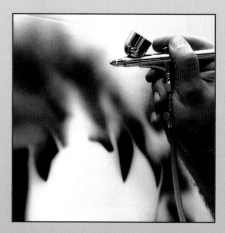

Gradually build up the dark areas. Reduce the distance to the base for working on the outlines of the flower and the buds so as to achieve more definite contours.

The picture can, of course, be turned, so that it is easier to guide the gun smoothly when working: many painters find it easier to make horizontal movements with the gun than vertical ones.

# Rose freehand project

Spray from the dark outline outwards so as to create a transition into the dark areas of the background. While working, keep reducing the distance to the base to emphasise the outer shape of the flower more clearly.

For this work, the needle cap has been removed so that paint deposits can be removed from the needle more quickly.

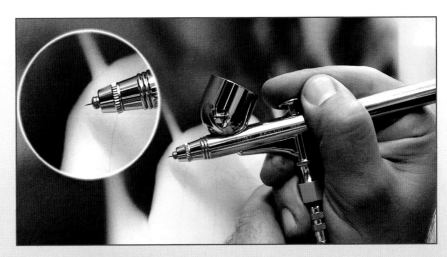

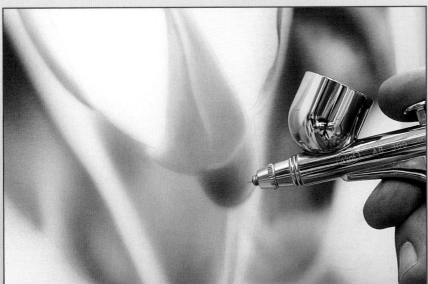

The leaves and dark areas of the rosebud are also sprayed with the same colour mix, but thinned a lot more.

With this design, not all areas of the picture should be sharp; this requires careful attention to the individual areas, ensuring the different degrees of sharpness or blurring are not lost through making the contours too even.

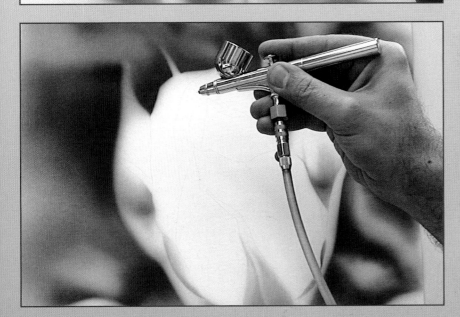

Once the dark areas of the picture have been sufficiently sprayed, continue with a mix of olive and yellow in a ratio of one part olive to two parts yellow, thinned with three parts water.

Proceed in a similar manner as before: work broadly at some distance from the base for large areas and at a closer distance for the contours.

# Rose freehand project

When working over the background areas, over-spray the previously sprayed dark areas with the new colour mix. This results in soft, harmonious transitions.

In this step, too, the work is performed at varying distances from the base.

The dark areas are sprayed closer to the base, whereas the light parts are sprayed from a greater distance. To spray the sharper contours, the paint mix can be thinned further with water. The thinner mix is easier and more precise to work with.

It is better to darken a line or a fade-out in steps rather than making a part of the picture too dark or too colour-intensive straightaway.

To do this, one edge of the eraser is first used to work on the outer contour of the flower, and then a transition is made to the surface of the rose using the wider part of the eraser.

A bright white surface is not necessary here; getting a sharper edge to the flower is more important. When working with the eraser, make sure that the surface of the paper is not damaged.

For smaller areas, the spray mist is removed with the eraser pencil.

The next step is to remove the spray mist at the edges of the rosebud using an eraser.

The colour for the rosebud consists of a mix of three parts fuchsia red, two parts crimson red, and twice the amount of water. Begin with the colour-intensive areas. Lightly mist a contour, then make the colour more intense and precise along the pencil line. The fade-out is then sprayed from the contour outwards, into the lighter area.

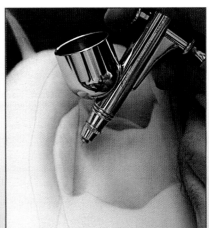

Once you have sprayed the fade-outs, the light texture of the leaves can be sprayed.

The fade-out for the texture is made by spraying at a greater distance from the base, and intensified by spraying closer up.

For this step, always pay attention to the various shades of the different surfaces, so that the flower is not too intense.

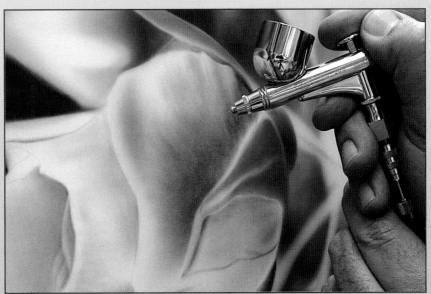

When doing detailed work, the needle tip needs to be cleaned more often, as the paint quickly collects on it when working in this way.

To spray the fine lines, the gun is guided slowly, close to the base, without much air pressure. The paint must be fed in very small amounts so that it does not run.

When working on the finer details, spray closer to the base.

The stems of the rose are sprayed with the same colour mix but at a greater distance.

# Rose freehand project

For the next step, the remaining paint is mixed with white to give a very light shade of pink.

This mix should be thinned with a little water so that the paint is easier to work with, but without losing too much coverage. This colour mix is used for the light edges of the rosebud, the buds and the areas of light in the background.

The light edges of the flower are sprayed very close to the base to avoid misting the neighbouring areas.

The light edges on the buds and the light areas in the background are sprayed at a greater distance to retain the blurred effect in the background.

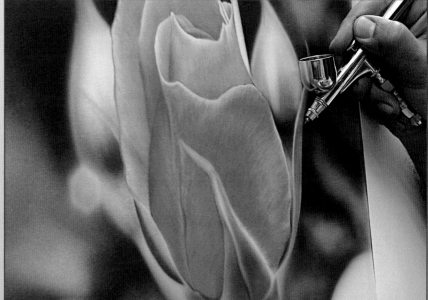

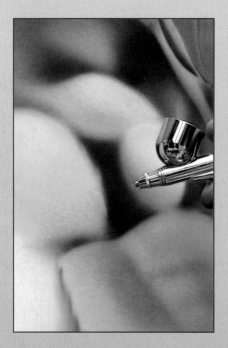

To work more on the leaves in the foreground, an opaque blue/green is mixed from one part olive, one part ice blue and six parts white.

Because of the high white content, this mix should also be thinned with the same amount of water to make the paint easier to work with.

For the following work on the leaves, do not spray the lines too finely. For all the blurred areas of the picture, work at a greater distance.

The light areas in the background are only lightly misted.

To make the light areas even lighter, the remains of the paint are lightened by adding more white. Use this paint to emphasise a little more the previously sprayed light areas of the picture.

Before doing any further work with the olive paint, the airbrush gun should be cleaned thoroughly.

When working with white, clumps of paint can easily collect in the nozzle area and cloud the new colour or clog up the nozzle.

The olive paint now used is thinned in a ratio of 1:1 with water. The dark green areas of the leaves, the buds and also the background are now reworked using this colour.

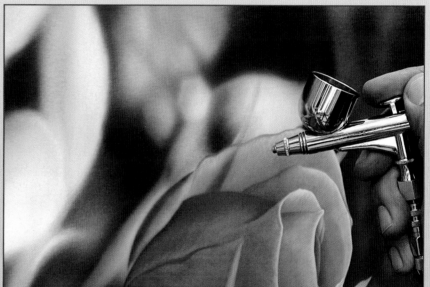

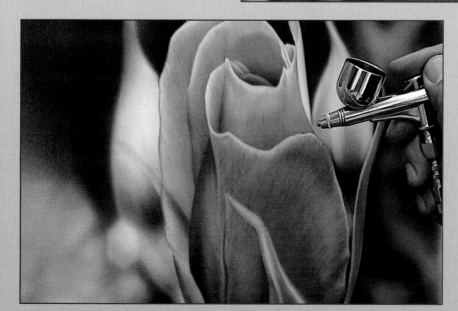

The next colour mix consists of one part fuchsia, one part crimson red and one part graphite, thinned with the same amount of water. This mix is used to darken slightly the areas of shade within the rosebud.

In this step, the contours are sprayed very close to the base again, and the fade-outs are sprayed from a greater distance away.

# Rose freehand project

When spraying the shadow areas, work very carefully so that they do not become too dark.

The paint can be thinned a little more with water, to be on the safe side, or the proportion of fuchsia and crimson red can be increased. This mix enables good control of the tonal values.

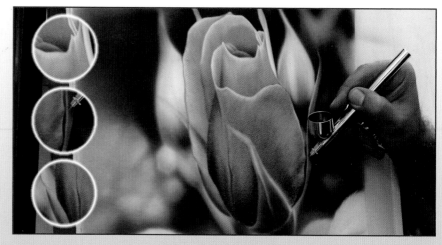

The same colour is also used for the spots and texture on the green leaves of the rose. When working on the details, the fine lines, and the slightly spotted texture, guide the spray gun very close to the base again. Here, too, pay attention to the combination of air pressure, nozzle diameter and thinning of the paint, and work very carefully.

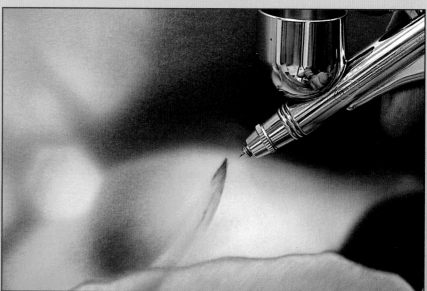

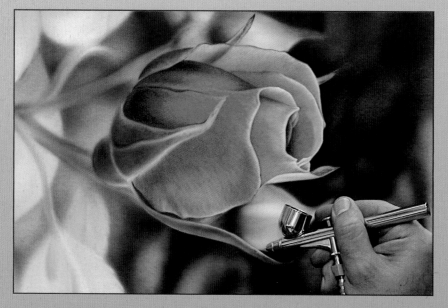

The work you have just done (intensifying the colour and the contrasts) changes the whole effect of the picture.

It is sometimes necessary to rework some areas. The buds and stems can be reworked with the same colour to accentuate the volume and make the colour more intense.

The next colour mix consists of four parts yellow, one part olive and one part white. The paint is thinned with the same amount of water.

Using this mix, rework all the yellow/green areas of the leaves. The paint should be used mainly in the foreground on the green tips of the leaves of the rosebud, the buds, and the rose leaves in the lower part of the picture.

The paint will cover straightaway if it is applied more intensely, because of the high pigmentation and the addition of white.

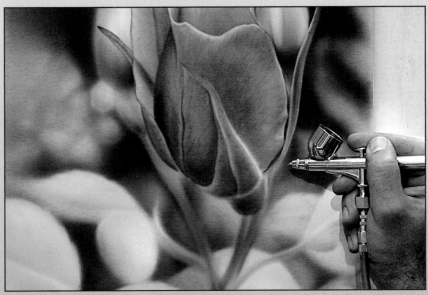

This has the advantage that areas on the green leaves that have been covered over by some of the pink spray mist can be re-covered.

The disadvantage of this paint coverage is that, with careless work, finished areas of the picture could be covered with paint and would then have to be reworked again.

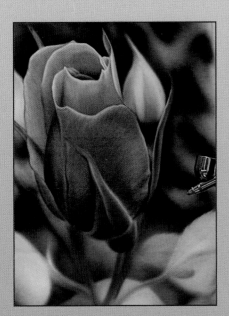

Use a mix of one part black and five parts water to darken the depths of the background and make the outer shape of the rosebud sharper.

Work close to the base again for the contours of the flower. In the background, the dark areas are made slightly darker by working at a greater distance.

# Rose freehand project

Make the light edges of the green leaves of the flower even lighter using a mix of one part yellow and one part white, thinned with four parts water. Make them a little sharper by working close up to the background.

Remember that the airbrush gun should be cleaned before changing colour.

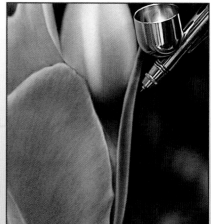

For the next step, thin one part white with two parts water. Use this to work on the light edges and the fine hairs on the green leaves of the rosebud.

The tip of the needle needs to be continually cleaned while doing this work, so that the fine lines can be sprayed cleanly.

Starting from the white contours of the pink rose petals, use the gun to create a transition to the leaf texture.

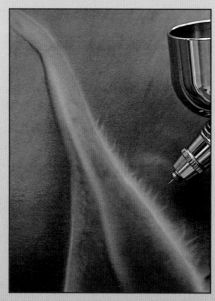

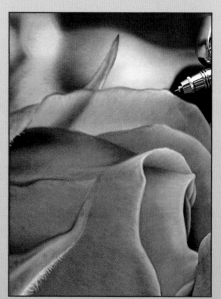

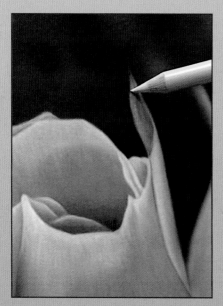

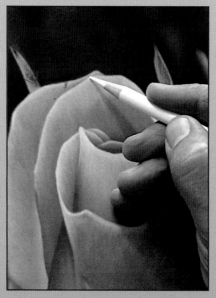

The subsequent finer details can be drawn using coloured pencils.

Emphasise some of the light edges again, and work on the fine edges, giving them a little more definition and increasing the contrast of one or two.

The colours that have been used here to complete the painting are yellow, white, pink, olive and black.

The finished work should be sealed to protect it.

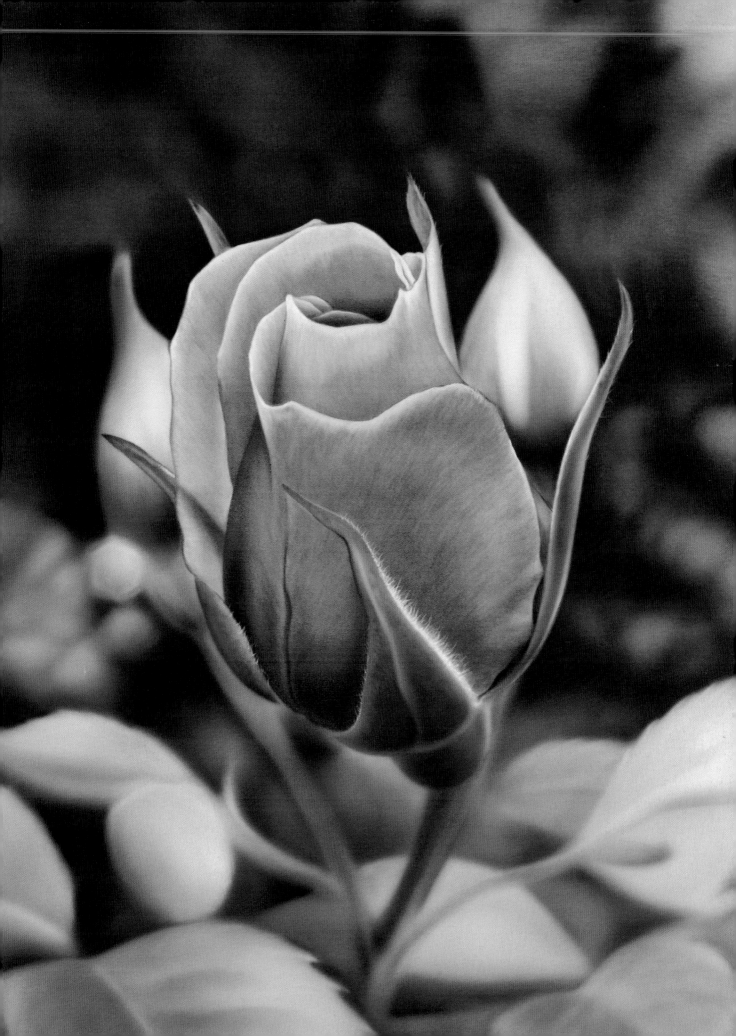

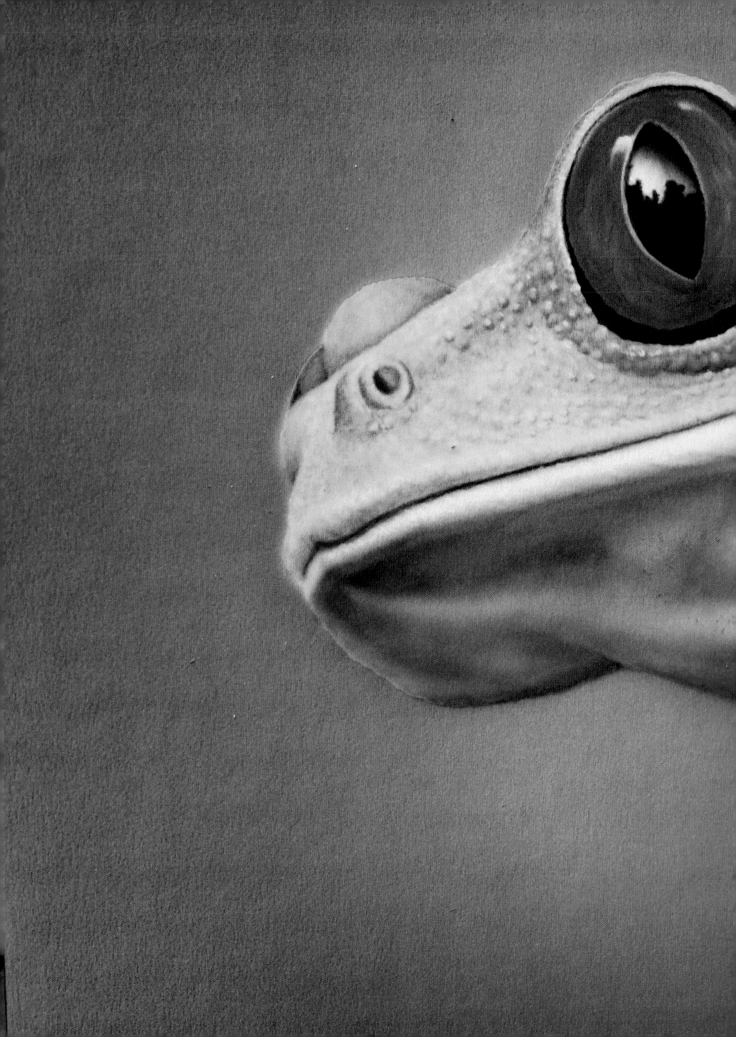

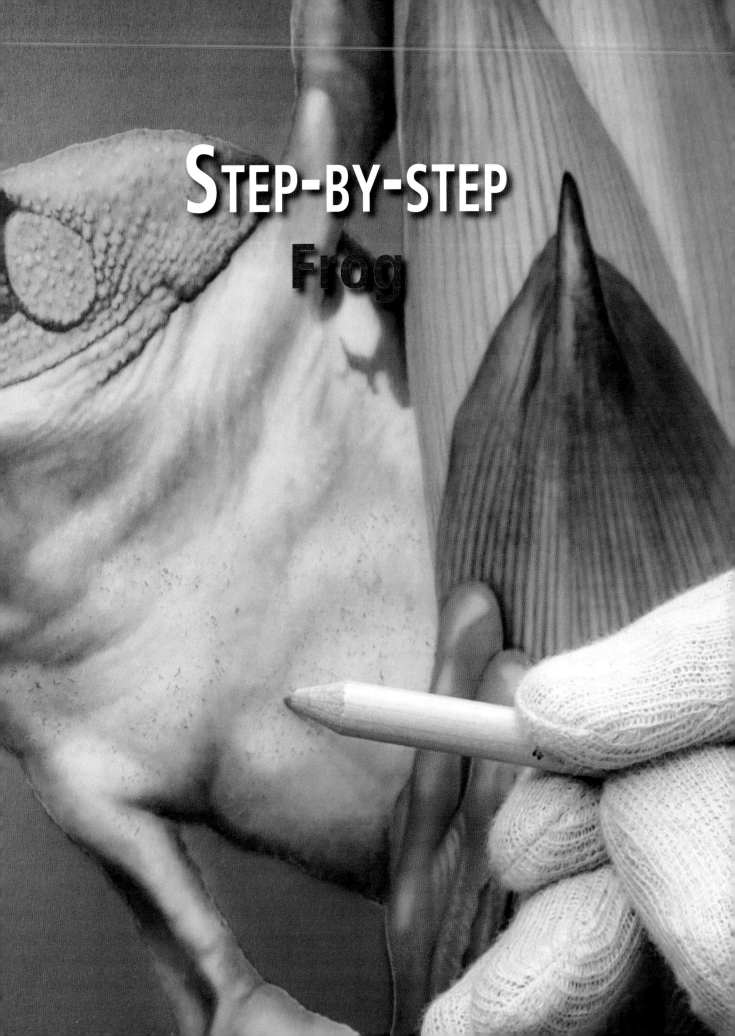

# STEP-BY-STEP
## Frog

# Frog project

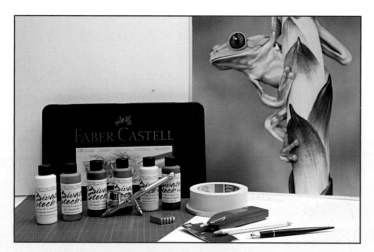

## The materials used in this project

E'TAC paints: opaque titanium white, naphthol red, opaque carbon black, phthalocyanine blue, arylide yellow and quinacridone magenta.

Airbrush: Iwata Custom Micron C.

Base: airbrush board, Schoellershammer 4G, 35 × 50cm (13¾ × 19¾in).

Eraser: Läufer Florett pen, electric eraser.

Coloured pencils: Polychromos by Faber-Castell.

Carbon paper for loose shields, magnets and adhesive tape.

Begin by creating an outline drawing to work from. This time, two A3 copies of this outline drawing are needed to make some loose stencils.

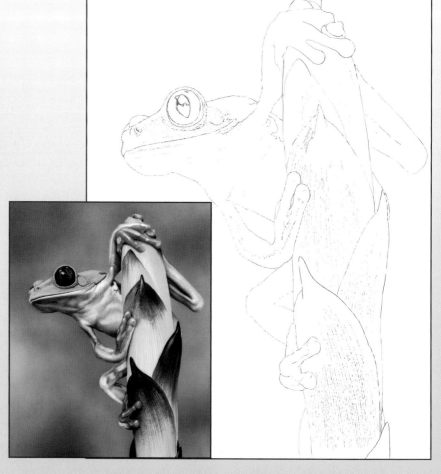

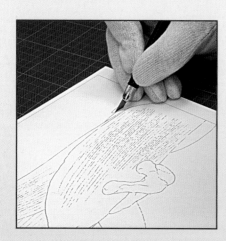

First, cut round the outline of the frog and the flower. The background of the illustration can then be sprayed quickly.

Next, cut out the masks for the tips of the leaves and the eye. These masks enable the strong tonal changes to be sprayed more easily and more quickly.

This work can, of course, be done without using masks or shields, but the use of loose shields is generally a great help for newcomers to airbrushing. They are also stable enough to be used several times.

It is advisable to use very fine lines when transferring the outline drawing to the base.

The loose shield is fixed to the base using magnets. Alternatively, small holes can be cut in the mask and covered with crêpe tape or masking film.

A further option is to use spray adhesive or mount, but special care must then be taken to ensure that no adhesive residue remains on the base.

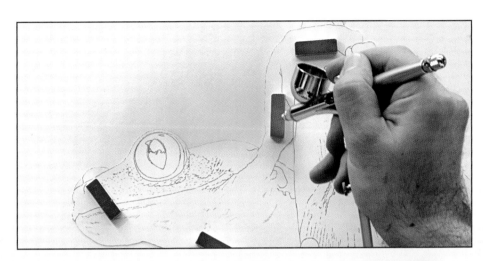

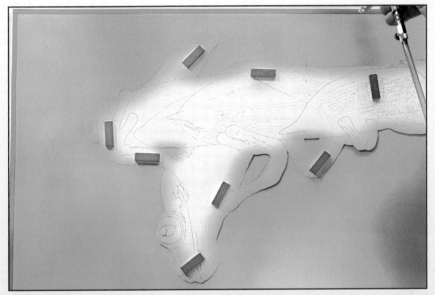

Spray the background with a colour mix of five parts cyan and twenty parts yellow, thinned with the same amount of water. Work at quite a distance from the base to avoid the formation of streaks. The background should take on a slightly cloudy character.

Some areas are sprayed more intensely with several layers of the colour mix, while other areas of the picture remain very light, but no longer white.

Then spray the background with a colour mix of one part cyan and ten parts yellow, thinned with the same amount of water.

Work at quite a distance from the base again. Use this colour mix to work again on the areas already sprayed intensely as well as the lighter areas. Here, too, it is important to avoid the formation of streaks.

The whole step is repeated with a mix of one part red, fifteen parts yellow and the same amount of water. This time, the

darker areas of the background are sprayed over more intensely, making them even darker.

# Frog project

Once the background is ready, the loose shields can be removed. As in this example, some spray mist can get under the stencil when working with loose shields. Before continuing to work, this should be removed with an eraser or with opaque white paint.

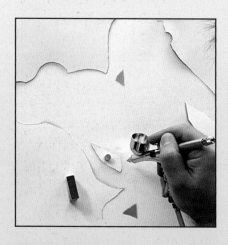

In this instance, the outer shape of the loose shield is placed on the picture, and the spray mist reduced using white paint.

Next, the previously prepared masks are placed on the base. Very precise work is needed here. The empty areas will help you align the mask with the drawing

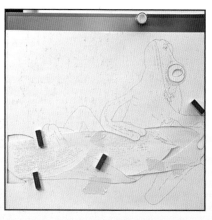

on the base. The previously cut out individual pieces are fixed with crêpe tape, so that they can be removed one after the other during subsequent work without having to remove the whole mask again.

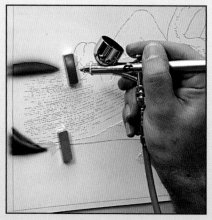

The work continues with a colour mix of one part black, one part cyan and two parts magenta, thinned with ten parts water.

The tips of the leaves are then sprayed dark. Remember that further layers of paint will be applied later, which is why the first paint application should not be too intense.

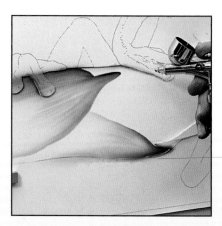

Uncover the masks for the individual leaves one by one, and then spray the dark areas of the picture, the tips of the leaves, the initial lines for the leaf texture, and the shadow under the frog's feet.

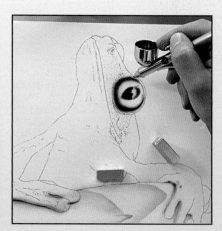

Use the same colour mix for spraying the pupil and the dark edge of the eye.

For this, apply the paint very strongly and close to the base, leaving the surface almost black. The light in the frog's eye is left untouched as far as possible. This light reflection will be retouched later using an eraser.

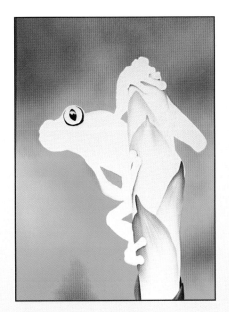

Using loose shields, complete the spraying. For those who are less confident, some more stencils can, of course, be prepared and used in the same way.

The individual raised areas are indicated by lightly misting a U-shaped shadow on the underside of each one.

These little shadows later form the surface texture of the top of the frog's body. Care should be taken here to work with very little paint, and the spray gun should be moved quickly enough to prevent the paint from running.

The shadow and textures around the throat and front of the frog are sprayed at more of a distance, using a light, circular motion.

Continue working with the same colour. To work on the fine textures and the slightly shaded parts of the illustration, the paint mix is thinned with a little more water. Depending on the diameter of the nozzle of the spray gun and the thinner, the air pressure can be reduced again. The shadow areas and the skin texture of the frog can now be sprayed, working very close up to the base.

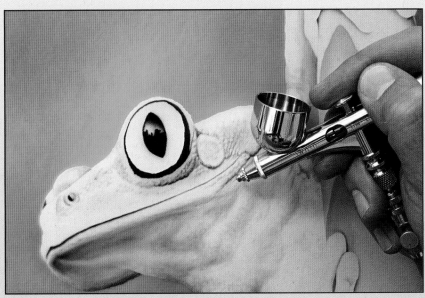

# Frog project

In a similar way, spray all the other textures, such as the lines on the leaves, the texture at the ends of the leaves, and the shading around the frog's feet.

Frequent cleaning of the needle tip is required throughout all this detailed work, so that the paint flow is not interrupted.

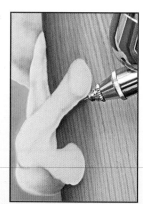

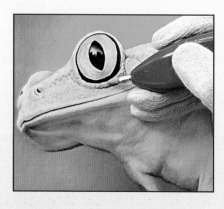

Once the shapes and textures have been worked on using the spray gun, the electric eraser can be used to make small areas of light and to remove spray mist from the light areas of the picture.

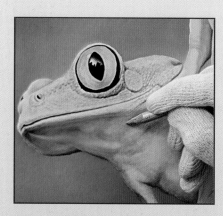

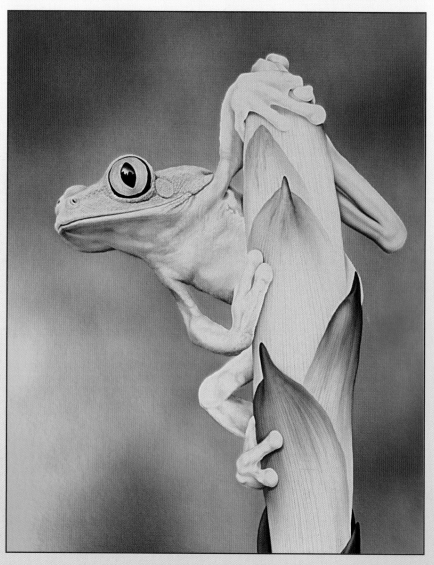

The eraser pencil is used to emphasise the slightly softer texture at the throat, front and legs, using small, circular motions.

After this has been done, all the shapes and textures should be easily recognisable.

For the colour work on the feet, mix a colour from one part red and eight parts yellow. This mix is thinned with some water. Rework the areas of the feet previously sprayed grey with this mix, and also work on the shape and volume of the individual limbs.

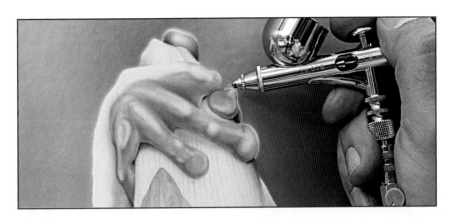

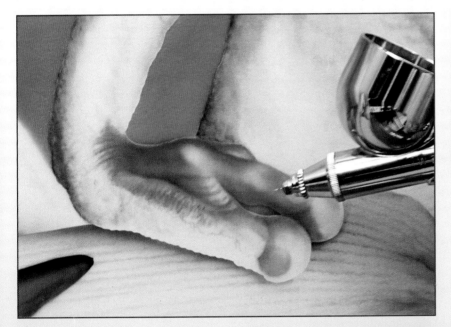

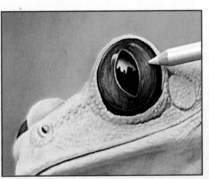

textures of the iris, and at more of a distance to mist the coloured areas. Reduce the light spray mist using an eraser pencil, and work on the detail of the texture of the iris.

By overlapping the individual layers of colour several times, the more intense red/orange shades are achieved. For this work, too, work close to the base to prevent the paint from misting over adjoining areas, such as the background.

In this step, the areas of light should be avoided as far as possible. Some places can be lightened again later using the eraser but, depending on the base, the paint spray can be held within the texture of the paper when erasing despite great care having been taken,

leaving a dirty mark. The eye is sprayed using red, thinned with two parts water. To do this, work both close up to achieve the fine

Using the same colour, make the red of the iris stronger.

# Frog project

The next colour mix consists of one part cyan, twenty parts yellow and ten parts water, and is for working further on the colour of the skin on the frog's head. The method of working is similar to that for the grey spraying undertaken earlier. The rough skin texture is now sprayed with colour, working very close up to the base.

The paint is sprayed from a little further away when working on the frog's throat and chin, so as to give just a very light shading there.

Depending on the intensity of the paint application, this mix gives a really light yellow/green with little paint, and a full blue/green after overlapping many layers.

The skin texture of the front feet and legs is worked on using small, circular motions of the spray gun. This procedure is repeated close to the base for all the limbs.

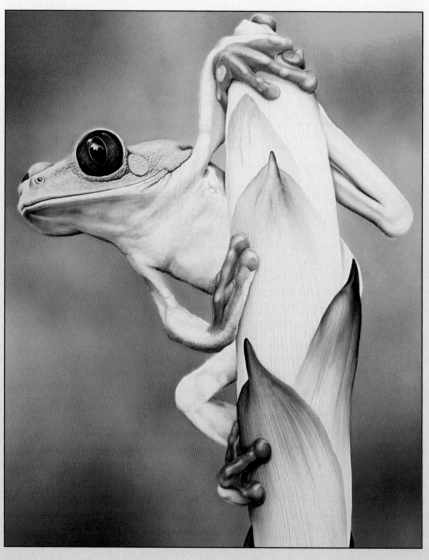

Next, spray the shading on the body of the plant and the veins of the leaf using the same colour mix.

For the colour-intensive areas at the outside edges of the plant, the shading is sprayed in one fade-out, starting intensely at the outside, and fading to light inside by increasing the distance from the base.

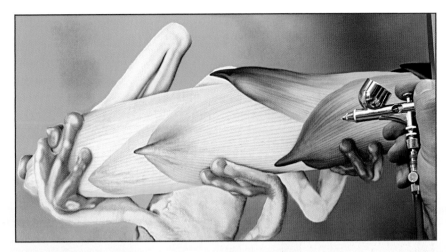

The last step is repeated with one part yellow and two parts water, to increase the colour of the leaves. The thinned yellow is then used lightly to rework the frog's feet and head so as to intensify the brilliance of the previously sprayed colours.

For the rest of the work, one part cyan and five parts red are mixed and thinned with the same amount of water.

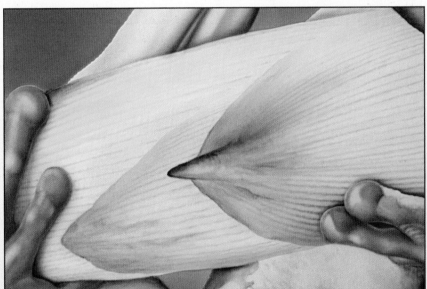

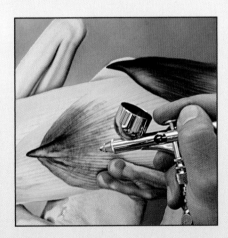

Work on the tips of the leaves very close to the base. Move the spray gun following the lines previously indicated. To achieve the various shades, some lines are only lightly misted, while others are sprayed several times more intensely.

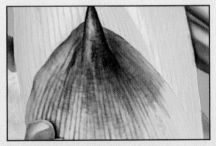

It is important, too, to rework more intensely the previously sprayed grey areas, adding some more colour across the lengthways lines, while following the shape of the leaf.

This mix is then used to spray the colour of the frog's throat, front, belly and legs.

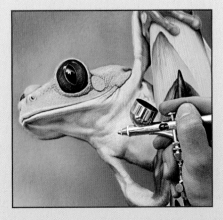

# Frog project

Continue working using one part cyan thinned with eight parts water. This transparent colour enables an extremely precise gradation of the very white colour fade-outs. Due to the significant thinning, each application of paint should always be allowed a little time to dry.

In this instance, the blue is sprayed on to the upper front leg, then the blue area of the frog's flank is sprayed, and then the blue of the upper front leg is made a little stronger.

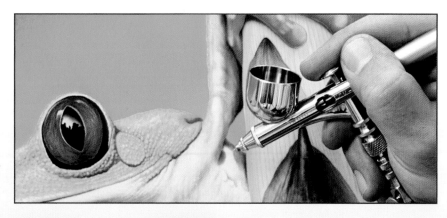

use an extremely economical application of paint, leaving just a light shimmering colour. If necessary, the paint can be thinned again for this purpose.

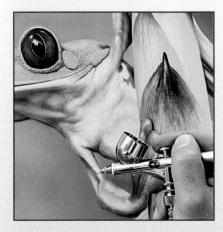

In this way, the blue areas are gradually built up. Here again, work close to the base. Texture and folds must also be taken into consideration.

To achieve the translucent texture of the throat and belly,

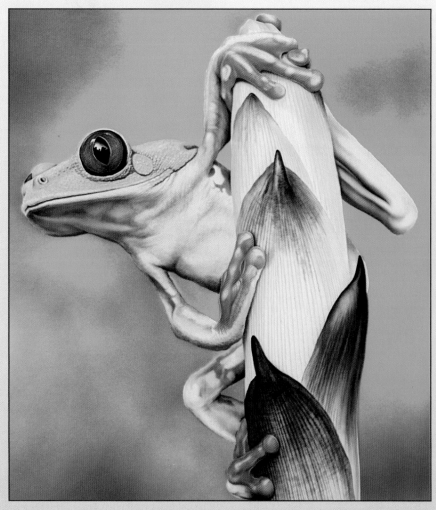

The final use for the cyan blue is to spray the lower leaf tips a little more in the areas of light. When doing this, try to achieve a smooth transition with the veins of the leaf.

The following steps use a colour mix of red and yellow in a ratio of 1:1 with the same amount of water.

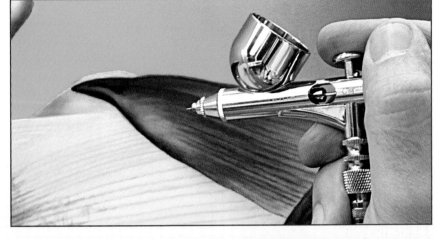

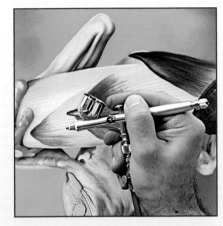

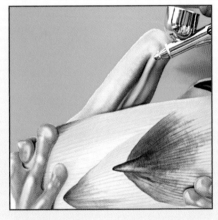

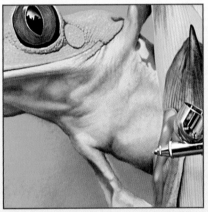

Spray the red/violet tips of the leaves intensely with this colour. Follow the previously sprayed texture of the leaves both lengthways and crossways again. It is important here to spray some lines very strongly and clearly close to the base, moving the spray gun slowly, as well as some soft fade-out lines done at greater speed and at a greater distance from the base.

Using the same colour, strengthen the eye colour. The yellow part of the colour mix

increases the brilliance of the red eye.

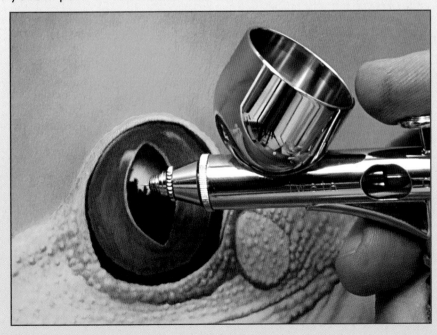

Next, do more work on the colour of the frog. First, spray the colour on the legs, front and throat in a very transparent fade-out, and then indicate the texture of the surface using a circular motion of the spray gun.

# Frog project

The next step involves working with various erasers. Using the electric eraser, remove the lights in the eye. Place the tip of the eraser on the edge of the black area and lift up from the base in an upwards movement. Working in this way will result in a soft transition.

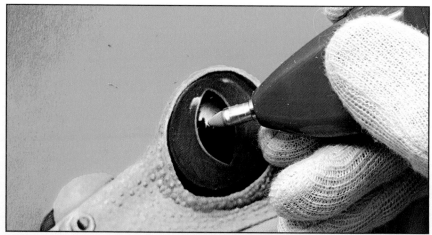

Using the harder side of the eraser pencil, brighten up the lighter areas within the texture of the head. The white lead of the eraser pencil enables you to carry out this kind of precise work. The different levels of light and sizes of raised markings on the skin are created using different degrees of pressure.

In this instance, the electric eraser is used to create the light points, as the soft, red side of the eraser pencil would need to be pressed down so much that several very small points of light would only be possible by continually sharpening the soft lead.

The softer textures on the frog are achieved with circular motions of the soft eraser lead. Lighter areas of texture can be achieved with firmer pressure,

or by repeating the process several times. If the desired effect is not achieved with the soft side of the eraser, the hard lead of the eraser can be used instead.

The fairly bright, fine points of light are achieved by using the

sharpened eraser lead of the electric eraser. The eraser will need to be sharpened several times. The points of light on all the legs and feet are created by working in the same way (very light, small spots using the electric eraser, and softer ones with the eraser pencil).

Once the textures of the frog's skin have been worked on sufficiently with the eraser, the colour of the frog should be intensified again with a yellow, thinned with the same amount of water. Spray the thinned yellow paint in small, circular motions, corresponding to the textural markings, working close to the base.

The colour of the top of the head is sprayed from a little further away. If a light spray mist falls on the background, this little bit of yellow will not cause a problem.

Intensify the top of the head with yellow, so that it will stand out more clearly from the background due to the stronger yellow/green.

Finally, rework the jaw bone and the underneath of the frog with the same paint. With this reworking too, spray the light fade-outs, such as the area beneath the jaw line, from further away, and spray the textures at the throat, front and belly closer to the base in a circular motion.

After spraying with yellow paint, rework the textures with the eraser pencil. This process includes not only the texture of the throat and belly,

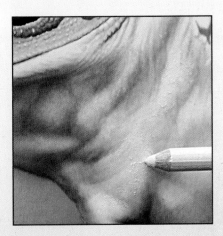

but also other areas of the top of the head, the jaw line and the front legs previously sprayed yellow.

# Frog project

Continue to work with the spray gun, using a mix of one part black and one part cyan, thinned with four parts water. Use this colour to make the dark colour of the pupil and the black edging to the eye stronger. Also, use this colour mix to paint over the line of the frog's mouth to make it clearer.

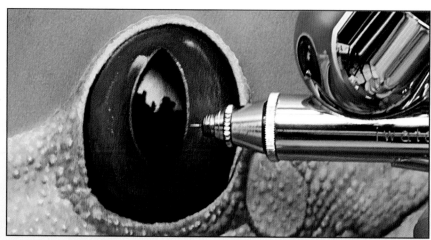

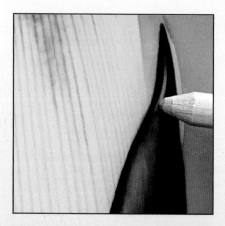

Using the eraser pencil, erase the remaining areas of light and strengthen the texture where

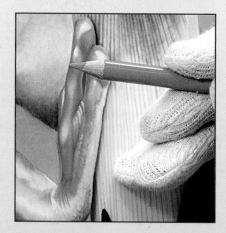

necessary. Use various coloured pencils to emphasise some of the edges more clearly. This can also be done with the spray gun, but would require remixing all the colours needed.

Making the final adjustments using coloured pencils enables you to complete the painting

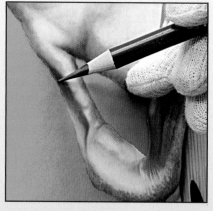

more quickly. However, the pencils used should, of course, match the colour of the paint sprayed. The pencil leads should not be too hard, or be used with too much pressure, as this could damage the base.

Depending on the varying intensity of the paint application, the surface of the work can be both matt and slightly shiny in places. To even up these differences, the work should be given a final seal. According to preference, this can be matt, satin or shiny.

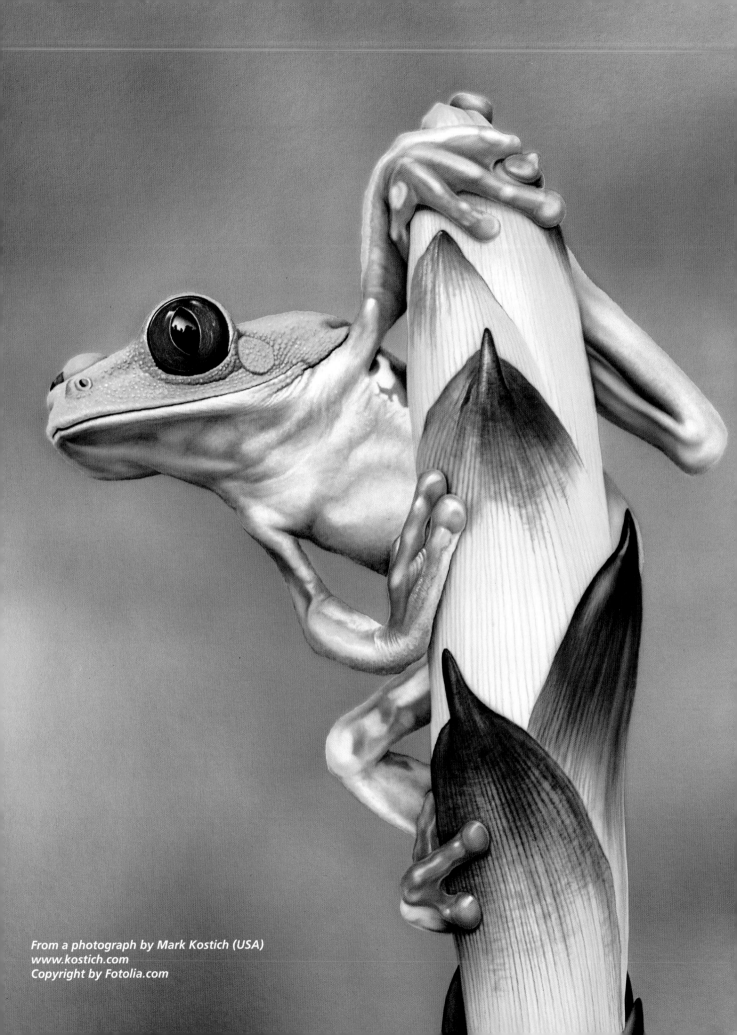

# STEP-BY-STEP
## Dog

# Dog project

## The materials used in this project

**Airbrush paints: Schmincke Aero Color Professional in sepia, olive green, brown Brazil, red madder dark, black, ultramarine.**

**Paint strainer, empty bottles, distilled water.**

**Airbrush: Badger Sotar 20/20, 0.2mm nozzle.**

**Base: illustration board, Schoellershammer 4G, 50 × 70cm (19¾ × 27½in).**

**Various erasers, sandpaper.**

**Coloured pencils: Polychromos by Faber-Castell.**

Begin by drawing the portrait of the dog. In this instance, the photograph has been enlarged using a projector and lightly sketched out with an HB pencil.

Work with the colour sepia for the first spraying. The colour has been thinned with three parts water and strained beforehand. For this work, it is important that the paint is very easy to work with. First of all, spray the dark areas of the eyes and the fur at a reasonable distance from the base.

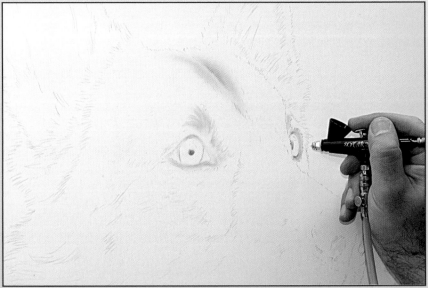

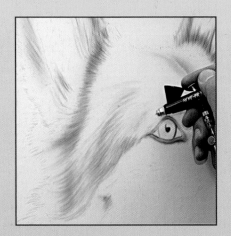

For this step, it is important to pay particular attention to the direction of growth of the fur. Each paint stroke must be evenly started and finished, so that there are no marks at the ends of the lines, as these would later make the whole effect appear speckled.

It is advisable with this work initially to spray lightly at quite a distance and then gradually reduce the distance to the base to get a better feel for the direction, stroke length and intensity of the individual lines.

In the next step, spray the nose and mouth with the same colour. Initially, indicate the rough shape, which is

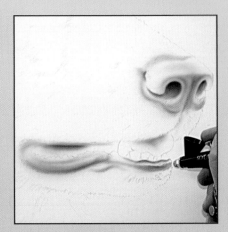

simply formed from broad fade-outs. Do not spray any of the outlines.

Continue to build up the rough texture of the fur by spraying the texture lines at a greater distance. These strokes, which are still very soft and light, are a way of slowly developing the final texture, which will later be overlayed with colour and detail.

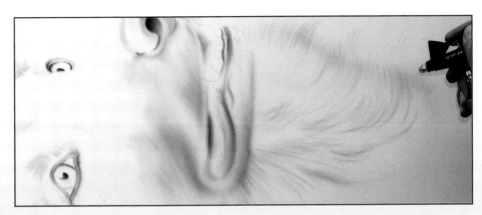

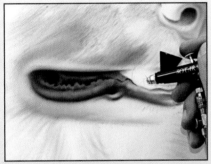

The next step consists of thickening the texture of the shorter fur, and continuing work on the mouth and nose. This is done holding the gun nearer to the base. Make the strokes for the texture of the fur gradually shorter and thicker, and the intensity around the mouth darker and sharper.

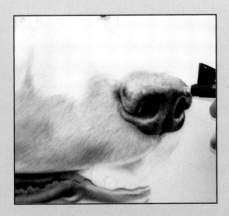

The texture of the nose is achieved by moving the gun in a circular motion very close to the base.

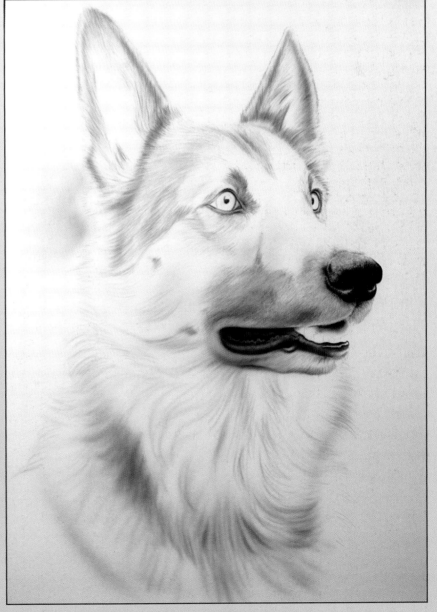

# Dog project

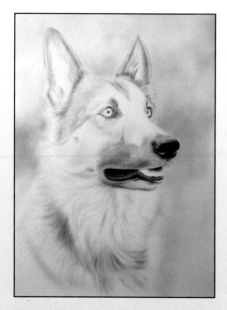

Spraying the background follows next. Working at quite a distance from the base, spray the surface with the same colour to achieve a slightly uneven and cloudy effect. Avoid too much spray mist falling on the dog's head, and also avoid spraying any of the outlines.

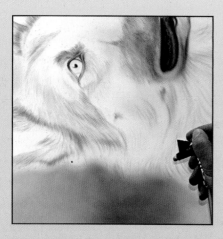

This step is repeated with the olive green colour, thinned with twice the amount of water. The green background is sprayed using very broad paint strokes.

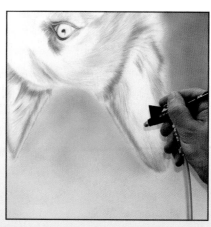

Tilt the spray gun so that the spray mist spreads from the dog's head outwards. Work very close up to the base when the gun is at the outside edge of the dog, with the distance becoming greater as the gun is moved outwards.

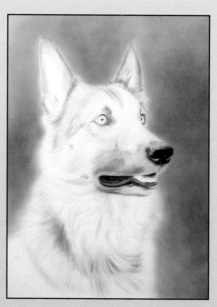

The background area should appear a little cloudy, but not speckled or streaked, and no areas should be left white.

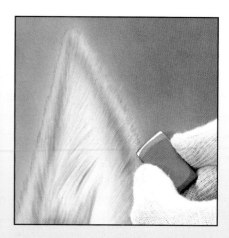

The outside edge of the dog is finally reworked with an eraser. Use it to remove some of the texture of the fur in the background area using closely placed lines worked in the direction of the hair growth.

Make the lines with the edge of the eraser. It may be necessary to reshape this edge several times with a piece of sandpaper.

For this work, use both the soft and the hard side of the eraser. This method gives the outer edge a soft, hairy texture, and any patches of unwanted green spray mist are reduced. This kind of edge would be very hard to achieve with cut masks.

For the next stage of the work, use the brown Brazil colour, thinned with two parts water. Use this mix to spray the colour for the eyes, suggesting the texture of the iris. In this instance, first spray a more intense line following the outer edge of the iris. From this line, spray fine lines to the centre of the pupil. By gradually adding more and more lines, the texture of the iris will develop.

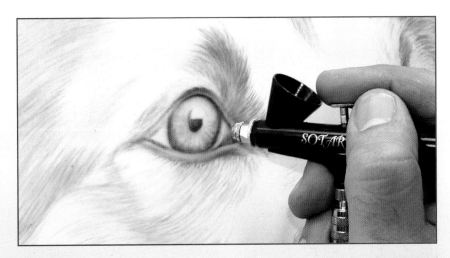

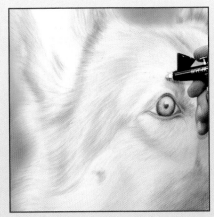

Using the same colour, work more on the texture of the fur. The lines must still follow the direction of growth of the fur.

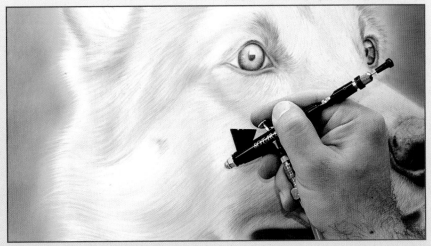

In the course of this work, the areas of short fur on the dog's face and the longer hair at the throat are all worked on again by spraying over the areas previously sprayed with sepia.

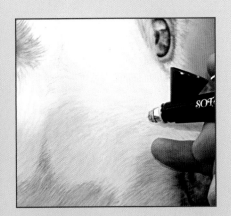

In this step, the texture is worked on closer to the base and by increasing the strokes.

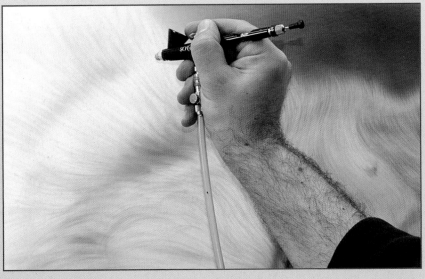

# Dog project

The texture of the fur is then improved using the eraser. As before, use both the soft and the hard side of the eraser to do more work on the lighter parts of the fur.

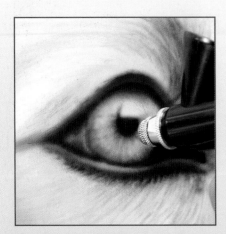

Rework the eyes using a mix of two parts water and one part sepia. Make the pupils darker, and improve the texture of the iris with fine lines running from the pupil outwards. Intensify the edges of the lids and the transition from the lids to the fur. This work is performed very close up to the base.

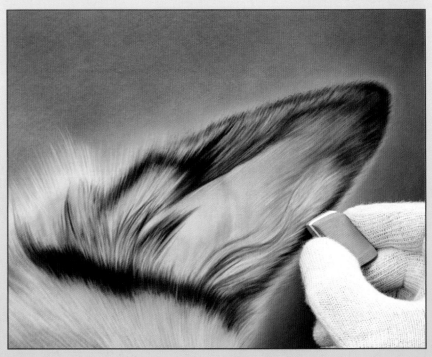

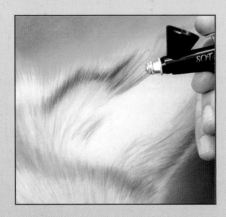

Use the same colour to work more on the very dark parts of the fur. Because of the minimal thinning of the paint, and the really fine texture of the hair, this step must be worked on in a very concentrated way, and the tip of the needle must be cleaned frequently to remove paint deposits, preventing blotting or spitting of the paint.

Depending on the airbrush gun used and the quality of the paint, increased thinning of the paint or increased air pressure can be helpful with this work.

The sprayed texture of the fur can be further improved using the eraser. A scalpel could be used instead of an eraser, but this does run a high risk of damaging the surface of the paper.

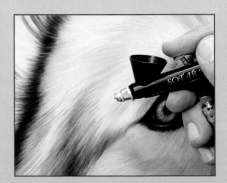

# Dog project

In the following step, the sepia paint is thinned with three parts water, and all the short hair around the mouth is sprayed from very close up to the base. Hold the spray gun at a sharp angle to the base, making it virtually impossible to start the fine, short lines with a dot. With this method of working, however, ensure that the nozzle cap of the airbrush gun does not leave any traces on the base.

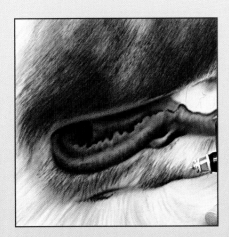

Spray the hair around the lower jaw in the same way, with the fine lines here being sprayed a little longer. Afterwards, spray the shadows between the teeth, as well as the fur at the throat once again.

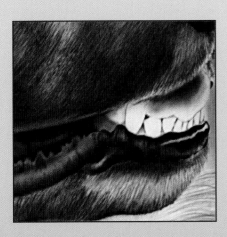

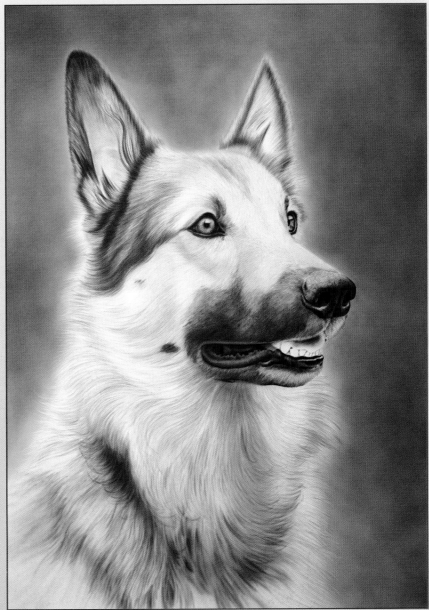

# Dog project

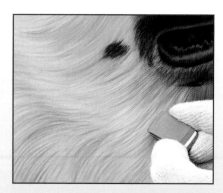

In the following step, the lighter parts of the fur are reworked with an eraser. For the longer fur at the throat, the soft side of the eraser is used; for the very light, short hair, the electric eraser is needed.

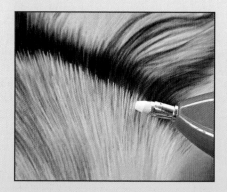

Using a hard eraser lead that has been sharpened at the edge with abrasive paper, very precise, fine lines can be erased. In this step, the light edges in the eye are also removed.

Alternatively, a scalpel can be used to emphasise the light hair, although care should be taken not to press too hard on the surface of the base. Carefully scrape the paint away using the sharp blade of the scalpel.

Thin a colour mix of one part sepia and three parts brown Brazil with five parts water.

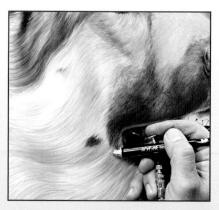

Use this mix to rework the texture of the fur over the whole picture. In places, lightly spray over the previously erased areas.

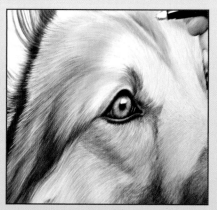

The paint is sprayed both broadly at some distance from the base to intensify the colour, as well as very finely and close up to the base to improve the texture of the hair.

When you have finished, erase some more hairs.

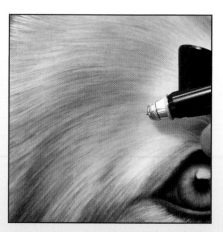

The next reworking is done with one part brown Brazil, thinned with three parts water, and is similar to the previous spraying. To increase the colour, some areas are misted a little more broadly. To improve the texture, more very fine lines are sprayed close up to the base.

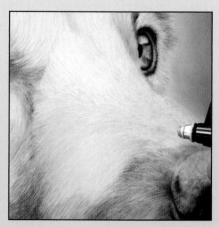

The area at the bridge of the nose requires a little more attention. The texture to be worked on here consists of very short, fine hairs. This surface is worked on extremely close up to the base, using very short strokes sprayed quite close to one another. For this work, the tip of the needle can virtually touch the base.

Rework the dark hair of the texture of the fur using a mix of two parts water and one part sepia. This work is done with the airbrush gun close to the base, and with a very slow movement of the gun, making each paint stroke very intense. It is important to ensure that the paint does not run when doing this.

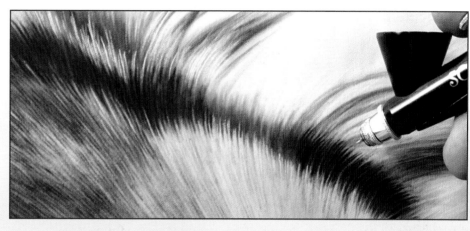

Using the same colour, rework the short fur around the mouth, too, which requires the paint to be thinned further. As for the bridge of the nose, for this texture work very close up to the base, spraying many closely laid, fine, short strokes.

For this work, the ratio of thinner to paint and the pressure set at the compressed air source should be taken into consideration. The thinner the paint, the less pressure is required.

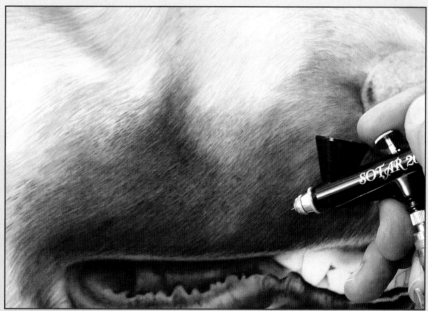

The dark places at the throat, chest and top of the body are then darkened with this colour, and thus the texture of the fur is improved.

These processes require one to alternate between the different areas of the picture, i.e. short fur, then long fur, so that the index finger does not become too tired.

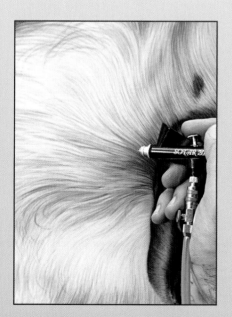

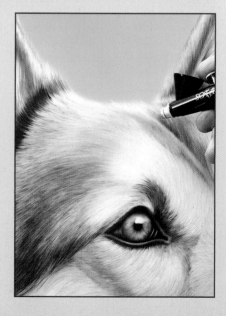

# Dog project

In the next step, the light areas of the fur are reworked again using an eraser and an electric eraser. In the throat areas and around the chest, the lighter hair is erased from the areas that were previously sprayed dark. The fur in this area should appear natural and soft. Working too evenly can result in the texture of the fur appearing too rough.

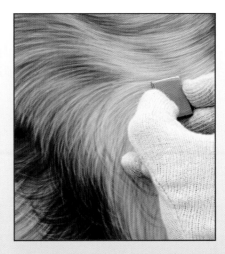
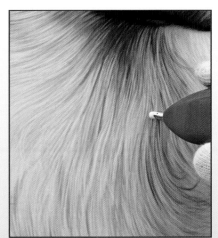

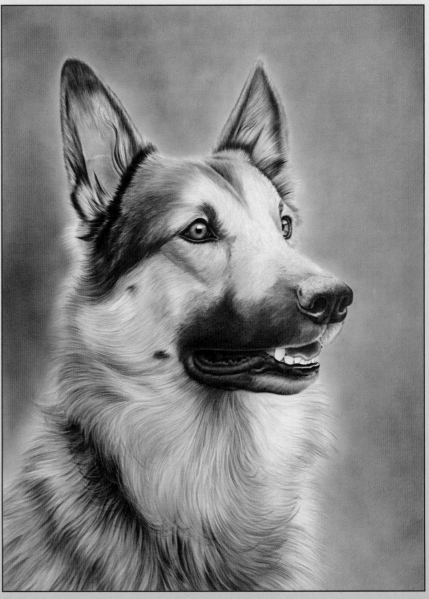

Finally, the dog's tongue is sprayed using a mix of one part deep madder red and five parts water. The tongue is given a slight texture with this work, similar to that of the nose, achieved by using a circular motion of the gun.

The lips and the inner area of the ears are sprayed over using broad strokes.

The dark areas of the dog are then reworked with black. Thin the paint with water in a ratio of 1:1 for the very dark areas of the pupils and the edges of the lids, as well as the nose. The work on the eyes is done very close to the base to avoid the paint from misting into the surrounding areas.

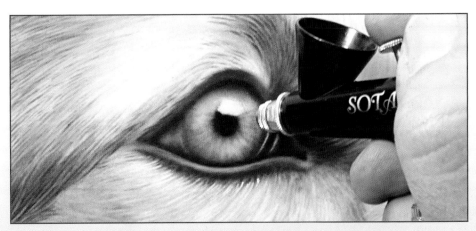

The reworking of the nose consists of making the nostrils darker, by spraying them darker above to lighter below; the reworking of the texture of the nose is improved with a circular motion of the airbrush gun.

Thin the remaining paint again with water to increase the texture of the fur. This colour is used to work further on the dark areas of hair over the whole picture from the ears to the throat.

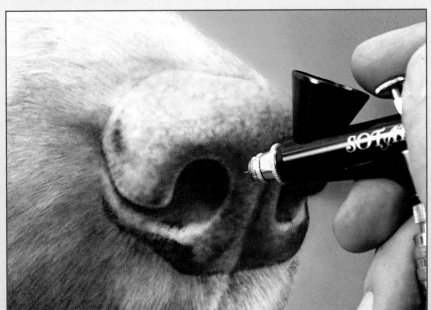

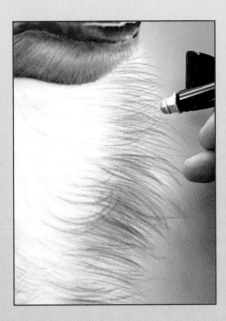

# Dog project

At some distance, lay a very translucent mist over the areas of shade at the throat and the reflection of the blue sky on the bridge of the nose. Use a mix of one part ultramarine, thinned with ten parts water.

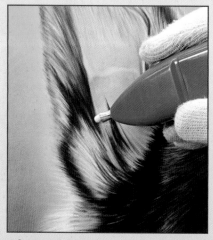

Afterwards, erase the light hair at the ears with the electric eraser.

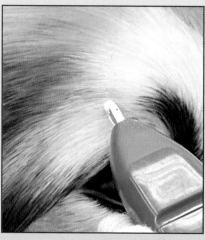

This is followed by a reworking of the eyebrows.

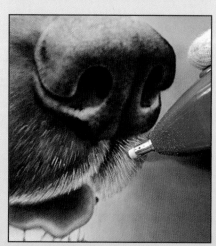

Using the electric eraser, erase some short, light hairs around the mouth.

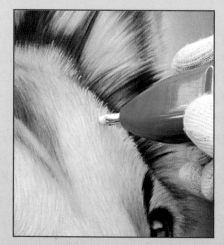

Then rework the short, light hair at the forehead.

Using a round scalpel, scratch out some hair around the mouth.

The texture of the nose is then lightened with the soft eraser pencil.

Place some hard areas of light on the nose using a soft lead in the electric eraser.

Use the soft side of the eraser pencil to remove the spray mist from the teeth.

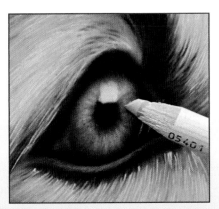

Lighten the texture of the iris a little and improve it with radiating lines.

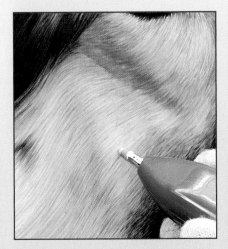

Rework other light parts in the short fur using the same tool.

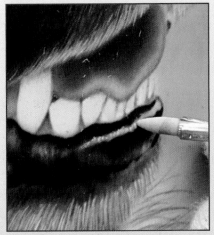

Place the hard, shiny areas of light on the dog's lower lip using the electric eraser.

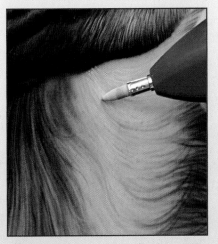

Increase the light hair at the throat using the electric eraser.

Indicate the texture of the lips using the hard side of the eraser.

Use the soft eraser pencil to work on the texture of the tongue.

Improve the texture of the short fur on the bridge of the nose with the electric eraser.

# Dog project

Improve the texture of the nose with a mix of two parts water and one part sepia. This work is done with the airbrush gun close to the base, and with a very slow movement of the gun, so that the paint application is very intense. It is important to ensure that the paint does not run.

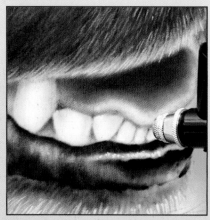

Use the same mix to emphasise the teeth a little more by making the shadows darker.

Then spray a few dark strokes in the texture of the fur at the throat.

Increase the hair again using a colour mix of one part sepia and three parts brown Brazil, thinned with six parts water.

Afterwards, improve the short fur also using this colour.

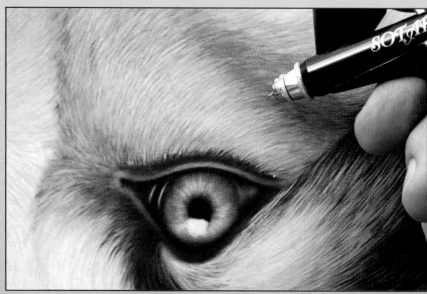

# Dog project

The fur is then reworked using the eraser. The texture is improved by creating different types of lines – light, fine and wide – using varying pressures when erasing. The edge of the eraser will need to be continually sharpened with sandpaper.

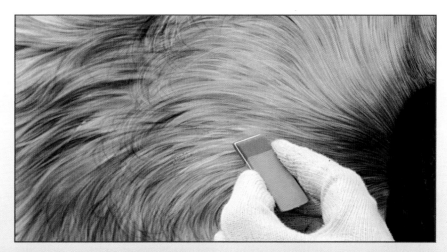

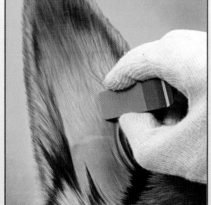

Add some lighter hairs to the ears with the eraser.

Erase the final points of light at the nose, teeth and lower lip. For these very thin lines, the lead of the electric eraser

should be continually shaped using abrasive paper. Add very fine, light hairs to the ears.

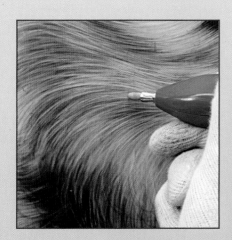

Using the electric eraser, place the final light and dark hairs at the throat.

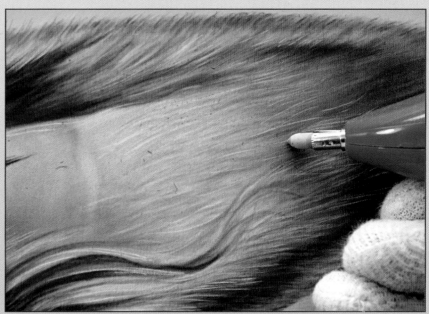

# Dog project

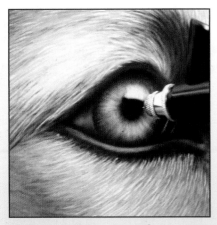

Using a colour mix of one part sepia and three parts brown Brazil, thinned with six parts water, complete the final details

for the texture of the iris, teeth and fur.

The last step consists of drawing the whiskers with coloured pencils. Sharpen the tips of the pencils at a slight angle and draw with the sharp edge. A very thin point would break easily, as the lines are drawn with a firm pressure.

Draw the first whiskers in dark grey; make some clearer in black. The lighter whiskers are drawn in light grey, with a black line underneath.

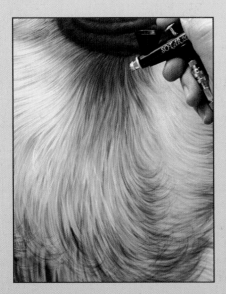

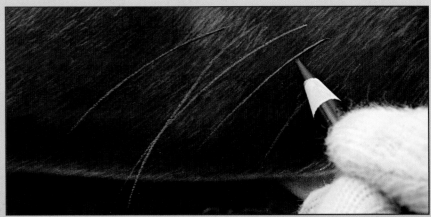

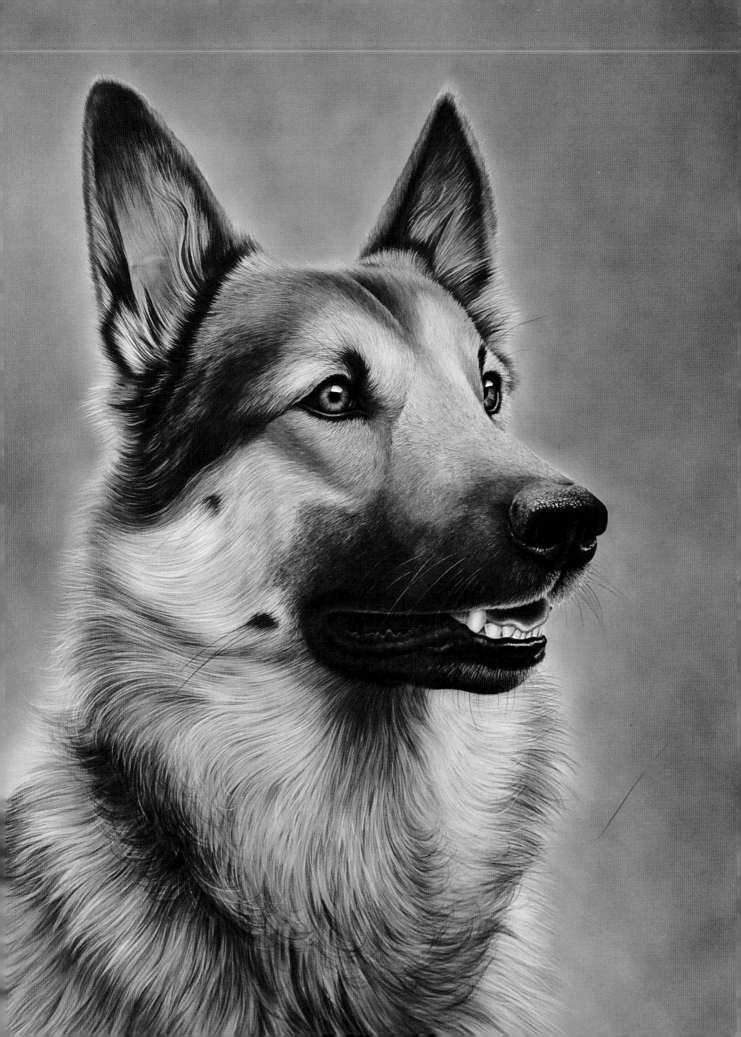

Shimon Peres, President of Israel

Robin Gibb (Bee Gees)

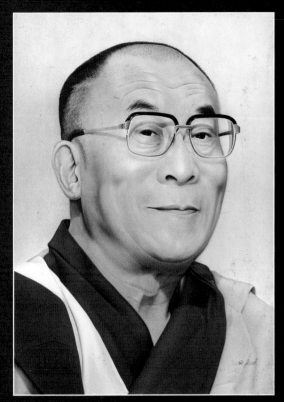

His Holiness the 14th Dalai Lama

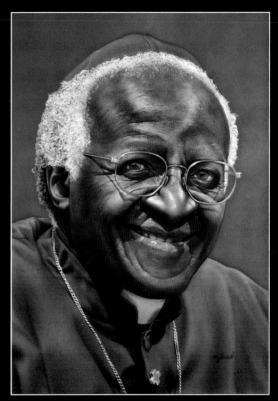

Archbishop Desmond Tutu

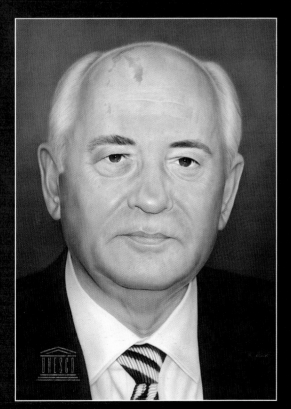

Michael Gorbachov

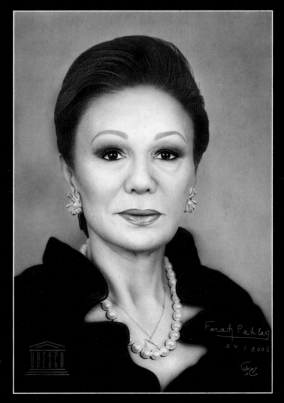

Farah Diba Pahlavi

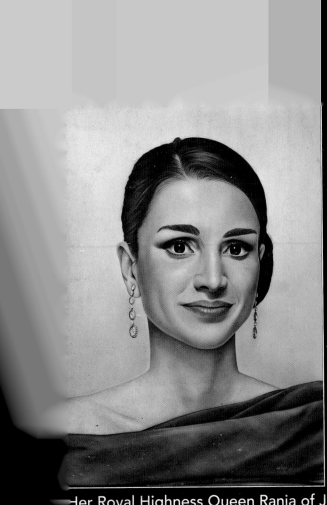

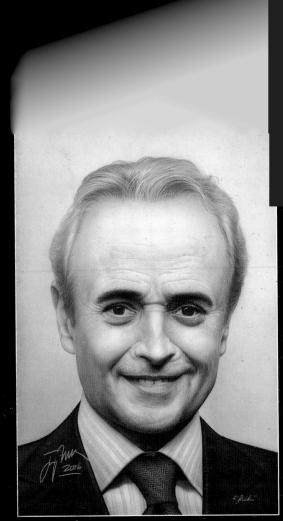

Her Royal Highness Queen Rania of Jordan

José Carreras

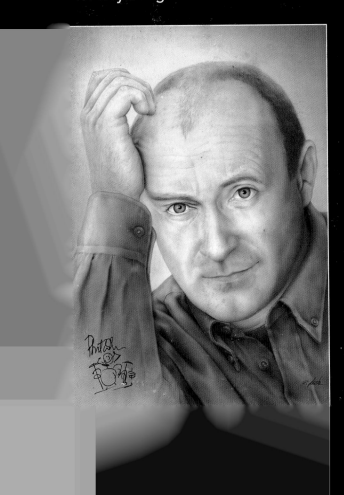

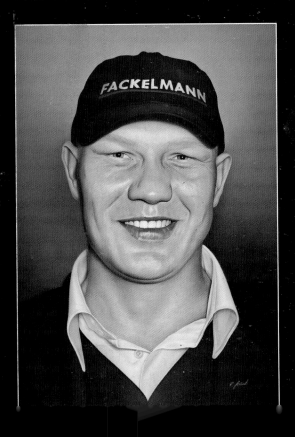